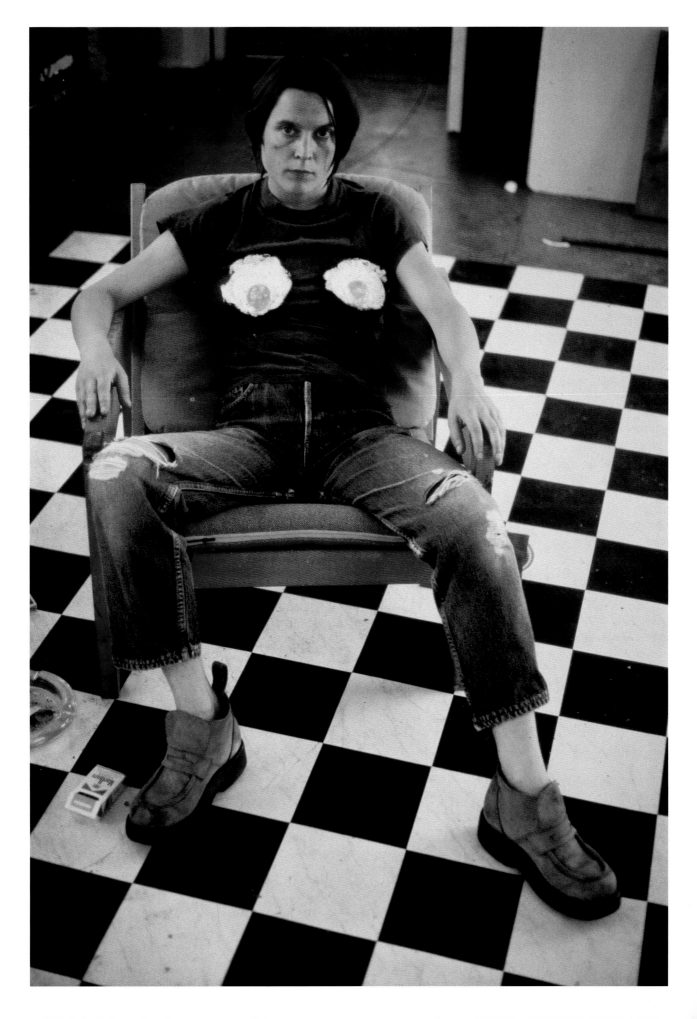

MODERN ARTISTS

First published 2002 by order of the Tate Trustees
by Tate Publishing, a division of Tate Enterprises Ltd,
Millbank, London SW 1P 4RG
www.tate.org.uk
© Tate 2002
British Library Cataloguing in Publication Data
A catalogue record for this book is available from the
British Library
ISBN 1 85437 388 9 (pbk)
Distributed in the United States and Canada by
Harry N. Abrams, Inc., New York
Library of Congress Cataloging in Publication Data
Library of Congress Control Number: 2002112231
Designed by UNA (London) Designers
Printed in Singapore

Front cover (detail) and previous page:
SELF PORTRAIT WITH FRIED EGGS
from SELF PORTRAITS 1990–1998 1999
Iris print on Somerset Velvet paper
57.5 x 54.8 (22 5/8 x 21 5/8)
Tate
Overleaf: AU NATUREL (detail, fig.63)
Measurements of artworks are given in centimetres, height
before width, followed by inches in brackets.

Author's acknowledgements

Thank you very much to Sarah Lucas for a lot of honest and
intelligent interviews. Also thanks to Emma Biggs, Melissa
Larner and Sadie Coles for interventions and editings.
Thanks to Pauline Daly at Sadie Coles HQ and to Gill
Metcalfe for getting in the pictures. And thanks to Mary
Richards at Tate Publishing for constant patience and
Sophie Lawrence for making the production happen.

Artist's acknowledgements

Thank you to Matthew Collings, to Sadie, Pauline and Sadie
Coles HQ, and to Tate Publishing.

SL

SARAH LUCAS

Matthew Collings

Tate Publishing

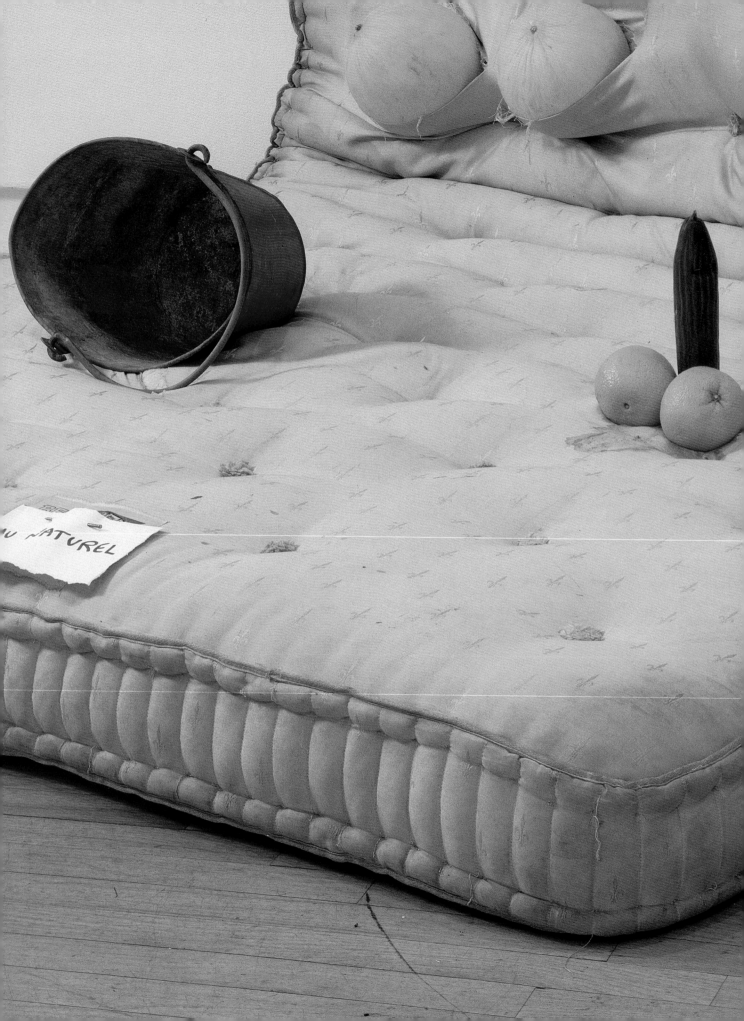

HUMAN TOILET REVISITED [1]
from SELF PORTRAITS 1990–1998
1999
Iris print on Somerset Velvet paper
57.5 x 54.8 (22 5/8 x 21 5/8)
Tate

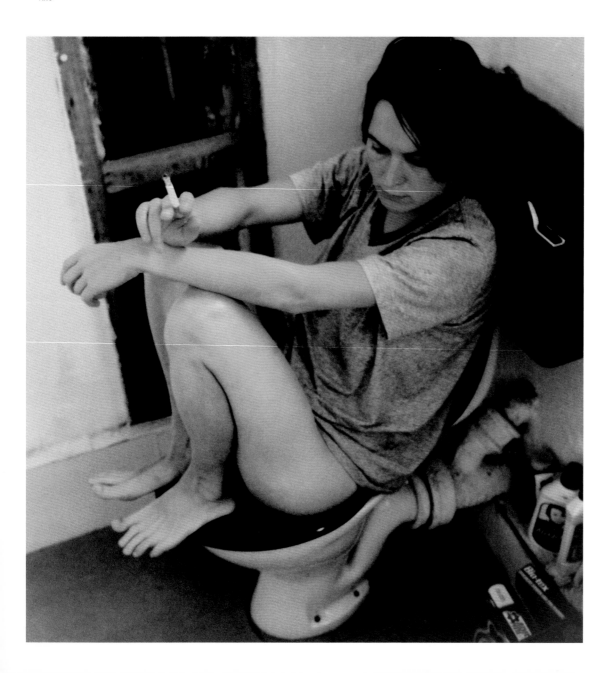

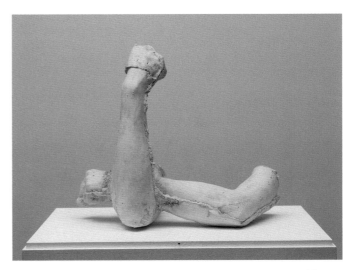

GET HOLD OF THIS 1994–5 [2]
Plaster
37.4 x 37.8 x 30.5 (14 3/4 x 14 7/8 x 12)
Sadie Coles, London

1

LET THERE BE LITE

In March 2002 I went up to the third floor of Tate Modern to have a look at a display of Sarah Lucas's work. It was like a mini-retrospective. Bearing in mind what an advance load of information one always has about this artist, because of her success, I thought I'd look at all the objects carefully one after the other and monitor my responses, to see if it was possible to have any fresh ones.

Human Toilet Revisited 1998 (fig.1) was a square-format photo about six feet high, showing Lucas naked except for a T-shirt, squatting on a toilet, knees up, heels on the front of the lowered lid, smoking. It had an all-over drained sepia colour, or non-colour. I thought its meaning was equally, a) perfectly normal: morning shit, and b) symbolic: life is shit (and maybe also: man treats woman as mere toilet). But b) was pure speculation and actually a) was questionable, since it would be odd rather than normal to sit on a toilet that way.

I looked out at the view of the rest of the work in the show. It was very satisfying in terms of colour: a theme of Old-Masterish subduedness: brown, grey, off-white, lemon yellow, dingy red.

The nearest work was a cast of Lucas's arms. One forearm and fist were in the air with the back of the fist outwards, the crook of the elbow thrust up against the wrist of the other arm, which made a solid horizontal across the vertical of the first arm; fist on one side, forearm and elbow on the other. It was clear even without the title – *Get Hold of This* 1994–5 (fig.2) – that the meaning was 'fuck you'.

I'd just read an article in a 1965 issue of *Studio International*, where some artists of the time discussed how meaning works in Anthony Caro's abstract sculptures. They asked things like, if a work expressed weightlessness, where was it – in the form, or in the viewer's perception of the form? Was content illusory at first and then perceptual? If Caro took weight for mass, did he leave the spectator with a kind of volume? As a document it was fascinating. It was clear the language was coded. It contained its own meanings, its own answers. Reading it in 2001, I wondered if the article had ever communicated anything at all. And now I thought, if *Get Hold of This* was a type of work that demanded a lot of questioning, instead of being obviously what it was, what would the questions be? Must anatomical casts always be noble? People sometimes say it's rude for a man to swear in front of a woman. Does that mean a woman would never swear? As the arms were Lucas's own, was it meant to be her gesturing, or was it a representation of a gesture that could be anyone's? It was a white, plaster object, cool and nice, the seams and edges left rough, as in classic modern art circa the 1930s. I wondered how the aesthetic dimension connected to the raising-issues dimension. Why not ask Lucas's dealer, Sadie Coles? I phoned her up later and she said: 'In *Get Hold of This* the aesthetics and the form are typical of her work – they're enough to get the job done, in terms of meaning.' That sounds right for the moment, I thought, just as those sculptors in 1965 probably thought their observations sounded right.

Beyond *Get Hold of This* was a colour photo of a ready-to-cook chicken (*Chicken Knickers* 1997, fig.5). The bird lay over the crotch of a woman, presumably Lucas, who wore nothing but white underpants. The placing was such that the vertical dark shadow of the chicken's rear made a disgusting visual pun. The photo's directness made it seem more connected aesthetically to Lucas's sculptures than to her self-portrait photos: the series to which *Human Toilet Revisited* belongs. These tend to have a processed look, grainy and degenerated – like a photocopy.

Installation at Tate Modern, London [3].
Left to right (wall): SOD YOU GITS
(fig.22), SEVEN UP (fig.4), WE SCORE
EVERY NIGHT 1992, WHERE DOES IT ALL
END? (fig.12), SELF PORTRAITS (fig.57)
left to right (floor): NUDE NO.2 (fig.9),
THE OLD IN OUT (fig.6), TRY IT YOU'LL
LIKE IT (fig.72) BEYOND THE PLEASURE
PRINCIPLE (fig.7), PAULINE BUNNY
(fig.10)

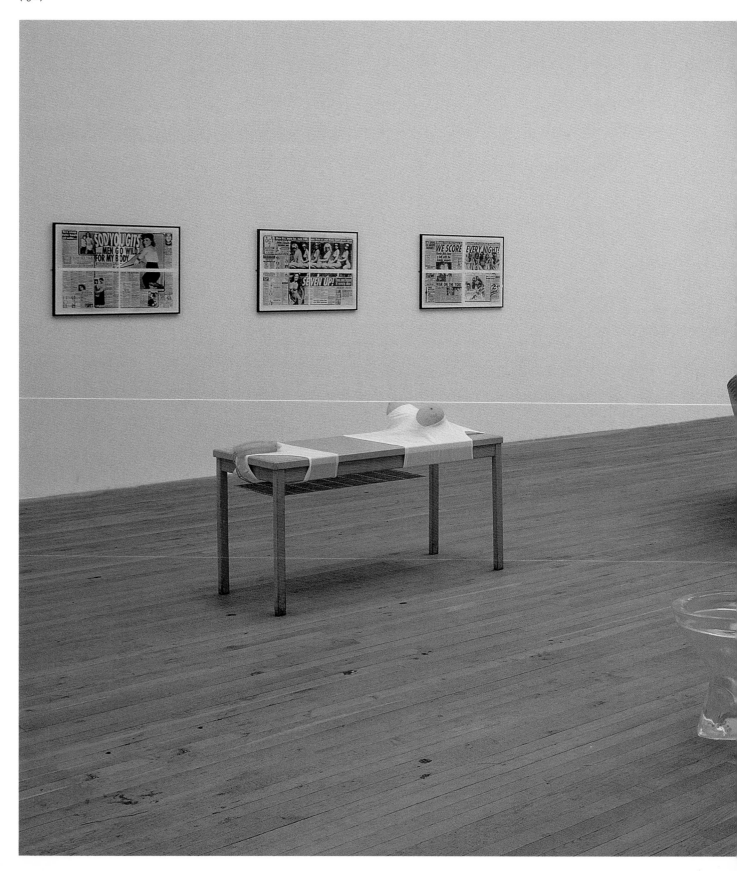

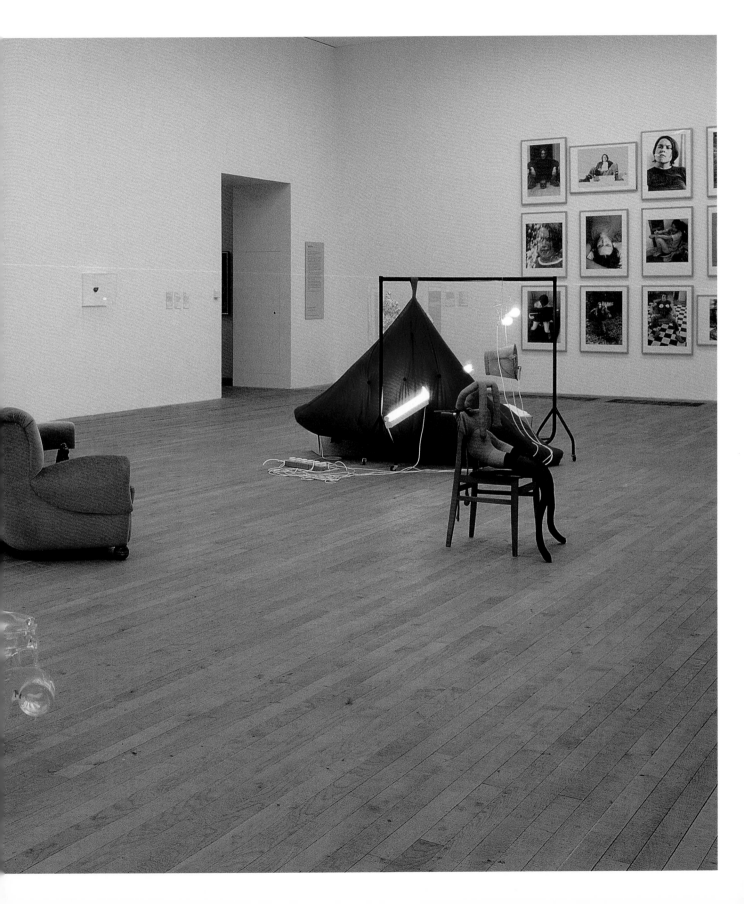

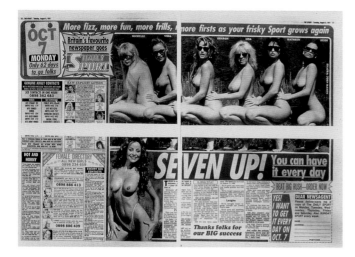

SEVEN UP 1991 [4]
Black and white photograph
Four parts, each 30.5 x 40.5 (12 x 16)
Tate

CHICKEN KNICKERS 1997 [5]
R-type print
Frame size: 42.5 x 42.5 (16 3/4 x 16 3/4)
Tate

Then I saw a row of what appeared to be actual photocopies, but which were in fact prints: double-page spreads from the *Daily Sport*, from 1991, with headlines that said things like 'You can have it every day' (fig.4). A dwarf in leather gear, holding a whip ('MIDGET kiss-o-gram Sharon whips her customers into shape and gives 'em plenty to smile about with her topless routine') suggested kitsch, something Lucas usually avoids – but which I associated with some garden gnomes I'd recently seen in one of her shows.

Between the *Sports* and me was a kind of roped-off pen, taking up most of the central area of this large room, with five sculptures in it, and a lot of empty space between them. Each sculpture was made of found materials (one was a clear-resin cast of a found object). The whole layout was nicely done: the slanting, the angles, the contrast of colours – a worn white table top, an electric light in a bucket – they all did something visually pleasing to one another.

I noticed that everything in the show – within the pen and beyond it – referenced the human body in some way. Sometimes the reference was so obvious you almost didn't see it. You had to come back to it later to realise it. For example, there was a spread of topless big-bosomed sex pots crouching in a field in one of the *Sports* – fat women, dwarves, perfect women, available women, available men ('HUNK OF THE YEAR!'), the *Sport* offers a lot of ready-made variations on a body theme. In this case, it is nudes in a landscape. The body reference was least direct in the case of a toilet cast in resin. Here the body was metaphorical: woman = thing through which stuff is flushed – as emphasised by the sexually suggestive title, *The Old In Out* 1998 (fig.6).

In most of the sculptures, the body was present as an easily decipherable cartoon-like schematic thing: ordinary objects from the home are arranged together

to make a symbol of a female body, occasionally accompanied by a male. Sometimes it was a body fragment: a cast of a part of Lucas's own body, with some kind of twist – so you saw an action initially (smoking, gesturing) and only subsequently made the connection with the body theme.

In Lucas's photographic self portraits the body was literal and direct – her own body, there before you – but sometimes with combined elements of metaphor and cartoon, as in a photo of her with a fried egg over each breast (*Self Portrait with Fried Eggs*, see frontispiece). In another one she posed with a human skull between her open legs (*Self Portrait with Skull*, fig.48); the skull is a metaphor for death, while its eye sockets made a visual pun on testicles, which I supposed might be a symbol for life. In these self portraits Lucas was very rarely unclothed, and when she was, nothing rude was revealed. But rudeness seemed to be always there – the photos challenged you to read in the kind of thing the *Sport* headlines spelt out.

I looked at *The Old In Out*. Francis Bacon and Marcel Duchamp are the two great masters of the toilet in art, I reflected, joined now by this new mistress, whose crappers usually stay close to the expected shape and colour. But this one was a departure from the norm – although, at the same time, a return to it, since it was cast in yellow, suggesting piss. It stood in front of a schematic white female figure, headless, made out of a rectangular wooden table: the legs were the limbs and the tabletop the torso (fig.9). Its breasts were a pair of pointy Honey-dew melons, jutting through neat cuts in a T-shirt pulled comically over one end of the white table.

I went over to look at this sculpture more closely. Apart from the melons, everything was white or off-white or grey. The secondhand-shop price tag was

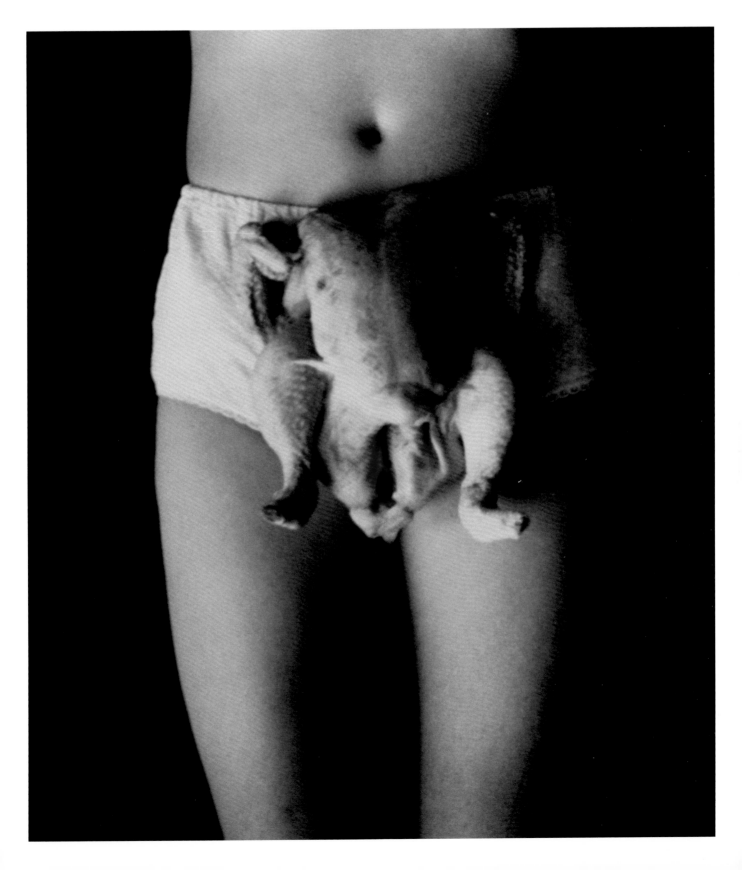

THE OLD IN OUT 1998 [6]
Cast polyurethane resin
42 x 50.8 x 36.8 (16 1/2 x 20 x 14 1/2)
Tate

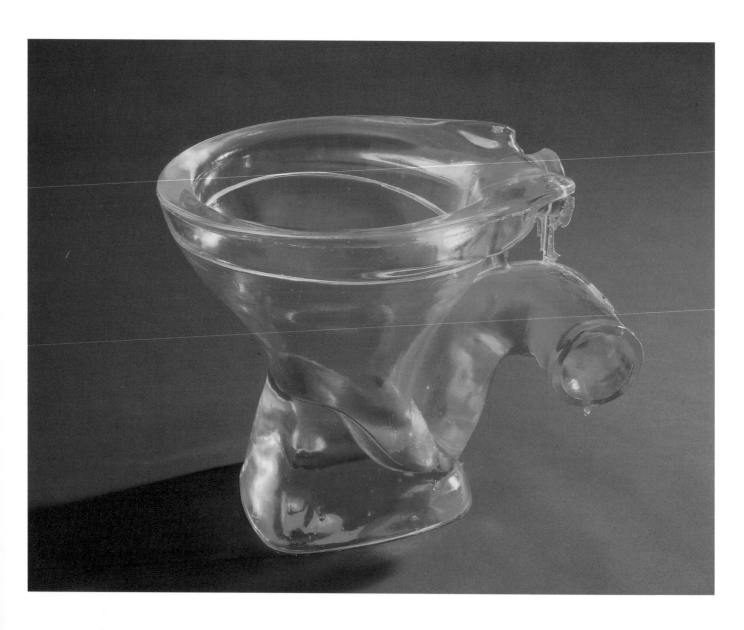

BEYOND THE PLEASURE PRINCIPLE
2000 [7]
Futon mattress, cardboard coffin,
garment rail, neon tube, light bulbs,
bucket, wire
145 x 193 x 216 (57 ¹/₈ x 76 x 85)
Tate

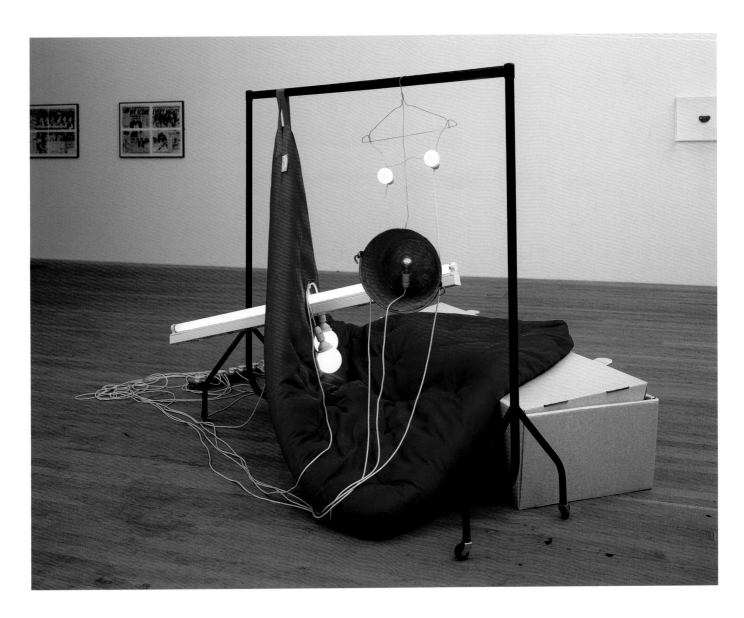

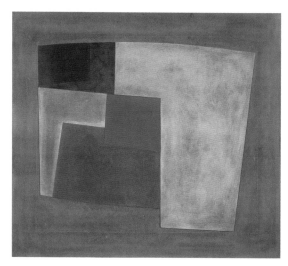

Ben Nicholson
1967 (TUSCAN RELIEF) 1967 [8]
Oil on pavatex on plywood
151.8 x 167.6 (59 3/4 x 66)
Tate

still on the table – '30DM', about £10. I assumed she'd bought it in the city in Germany where she'd been invited to exhibit. I supposed she'd just got all the materials together there, and then made everything for the show. White underpants were pulled over the other end of the table. The brush-ends of two old-fashioned bottle cleaners lay over the crotch of the pants, their wire handles bent underneath the table edge. The brushes made a grotesque symbol, like a primitive graffiti drawing on a toilet wall of a pair of parted swollen hairy lips. But there was something pleasing about the white on white. In fact the whole arrangement, which, since it was a table, was a parody of a still life as well as of a nude (it was called *Nude No.2* 1999) suggested gentlemanly mid-twentieth-century English abstract painting. It was an arrangement of objects, not a painting, but the contrasting textures, the play of curves and rectangles and shapes and intervals – the confident decorative flatness – were like the tastefulness of St Ives painting, like a Ben Nicholson (fig.8). I thought Nicholson would be a horror name for trendies, because non-ironic abstraction is now seen as a loser stream of art. Magritte would be a more acceptable reference, because Surrealism has renewed intellectual credibility. But I reflected to myself that it's the rarely discussed visually abstract side of Lucas's work that gives depth to its easier to assimilate aspects.

Over towards the middle of the pen was a green fake-velvet sofa (fig.72, p.95). Breast-symbol melons (lighter green) poked through the backrest over to one side, while in the middle of the seat a phallic form jutted upward. I couldn't make out what it was until I moved over a few yards and then it became clear it was brown meat. If it had left blood on the velour surface it might have suggested female bleeding, but in fact it was dry and hard, and I reflected on how

thoughtful, intelligent and carefully constructed these arrangements of objects were. When I got round to the other side of the pen, I saw that it was called *Try It, You'll Like It* 2000. But before I got there, I stood opposite *Pauline Bunny* 1997 (fig.10).

This was another headless female, this time made of stuffed tights clamped to an office chair. The black stockings were amusing. I thought it was a representation of female subjugation as abjection, which is quite punky (since impotence or powerlessness is a theme of punk). I thought of the 1963 photo of Christine Keeler on a modern chair. And I don't know how I possess this knowledge, but I'm sure there used to be something called a 'water bunny' in women's public lavatories, which was for disposing of used sanitary towels; an appropriate association given the recurring theme of male disgust at female sexuality.

Behind me was a set of photos showing the same sculpture in the artist's studio in high-contrast back and white, with strong lighting (*Black and White Bunny 1, 2 and 3* 1997). There was a rhyme for this bright-light effect in the sculpture pen: electric illumination from a work with a Freudian title, *Beyond the Pleasure Principle* 2000 (fig.7). In this work a female figure was made up from standard domestic-use light bulbs, hanging from a wire coat-hanger – the hanger was attached to a fire bucket with a single red-tinted bulb within. A fluorescent tube with two large dangling globe-shaped bulbs made up a male. Both were accents within an arrangement of open and closed more-or-less rectangles: a black clothing rack on wheels, a red futon hanging from the rack by a strap, and a cardboard coffin (white, with black straps) lying flat on the ground. A corner of the futon was laid over the coffin. I thought they were obvious, ordinary objects, but also sculptural versions of the kind of over-lapping abstract coloured planes you find in Cubism. I

NUDE NO.2 1999 [9]
Table, underwear, melons, brush
60 x 120 x 60 (23 5/8 x 47 1/4 x 23 5/8)
The artist and Sadie Coles HQ,
London

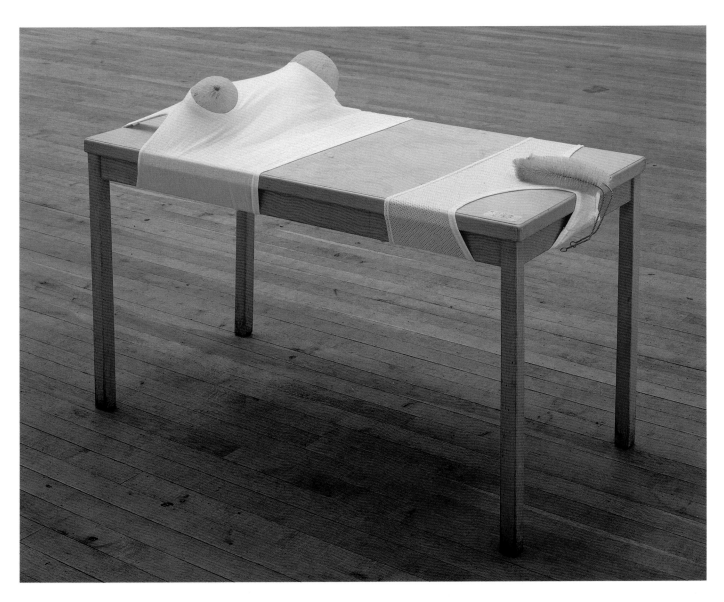

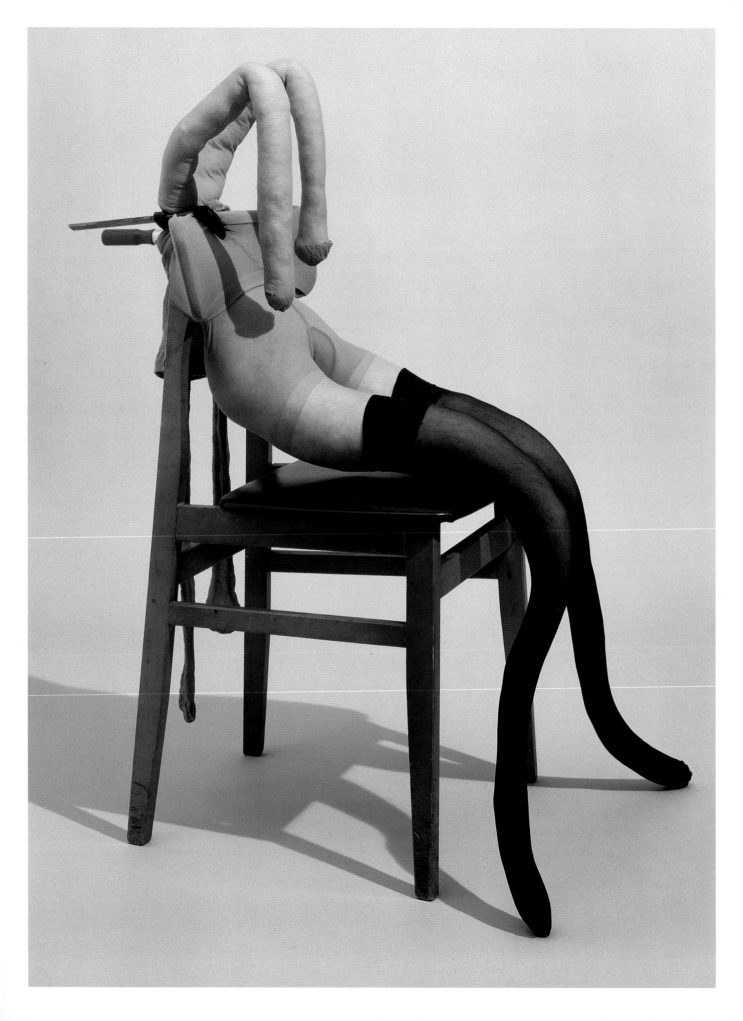

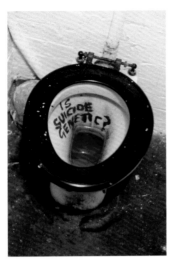

PAULINE BUNNY 1997 [10]
Tan tights, black stockings, wood
and vinyl chair, kapok, wire
95 x 64 x 90 (37 ⅜ x 25 ¼ x 35 ⅜)
Tate

IS SUICIDE GENETIC? 1996 [11]
C-type print
50 x 40 (19 ⅝ x 15 ¾)
Tate

also thought the whole thing could be a modern version of a religious painting, an assemblage-art answer to a Renaissance *Pietà*.

It was good enough that Lucas made you see sex in a pile of junk, and that the play of objects and signs was economical and witty, but you could always read in a bit more: the female and the male united on the rack; the end is always near. I thought of Freud's theory of conflicting drives: *eros* and *thanatos*, love and death. But this might be over-doing it. Freud is all metaphors, while this bit of arrangement-art was all bluntness. Or it might be more true to say it produced a different set of metaphors, not a single ponderous one for something already enshrined in intellectual life, but new ones for what we actually are now. Penetration, tearing, piercing, rusty old buckets, love lights turned on, emptiness, death, 'racked' existence, undisguised yards of trailing wires (the inner workings exposed) – it was a circuit of ideas, all of them coming through in a lively way, because of the work's sculptural liveliness. They stood for the new breezy relationship we have with what is fundamental and inescapable: death-lite, sex-lite, plus (bleak, alienated, lonely) existence-lite.

I thought *Beyond the Pleasure Principle* – this sculpture of 2000, rather than Freud's essay of 1920 – had nothing more profound to say about sex and death than a Benetton ad campaign. But it comes from an art tradition (the side of modern art that is about assembling and arranging) and art has its own seriousness. And this was why the work was compelling – not because of its literary meanings, but its visual ideas.

On a wall beyond the pen I saw a single photo showing a medium close-up view onto the inside of a grubby toilet bowl (fig.11). A question was painted in capitals, in brown on the white china: 'IS SUICIDE GENETIC?' It was a daft and semi-grim sight, too daft

and stagey to be wholly grim. But if the muted colour of the sculptures in the pen was Old Masterish, then this photo (*Is Suicide Genetic?* 1996) was like Spanish painting: pleasing, hazy black and white, dark brown, donkey-grey and greeny off-white.

Nearby were twelve photo self portraits, arranged in a single irregular rectangle about eight-feet square. In each, Lucas posed in a way that was unaffected and natural but at the same time, in many cases, the situation was obviously absurd – for example, a shot of her standing in front of a public toilet with a very large fish over her shoulder (*Got a Salmon On #3*, fig.38). Several of them showed her smoking; in one she ate a banana (*Eating a Banana*, fig.13). The art of them was to avoid a formula. If there were one, it would be variations on a theme of dumb insolence. Throughout, her expression was glum, not over-played like a mime artist, but down to earth like someone with a hangover.

Now I found myself confronted by a gnome pushing a wheelbarrow, the entire form clad with glued-down cigarettes (fig.14). Light played on dried specks of adhesive. (When I first saw this work it was in a gallery lined with wallpaper that had a sex/life/death theme: breasts made of cigarettes.) Garden gnomes are either kitsch, which is classless, or else they have nostalgic working-class associations. They are not normally sexual but suburban. But 'suburban' often implies 'repressed', which suggests sex. This one was titled *Nobby* 1999. It was originally shown with others, made in the same year, called *Willy* and *Dickie*. I felt the cigarette-coursing was very aesthetic, irregular yet balanced-out. The ochre filter tips made a pulse that rippled along, simplifying the form, making you enjoy its unlikely, chunky, right-angled geometry. The cigarettes sometimes followed the detail of form, with little bent cigarette-circles follow-

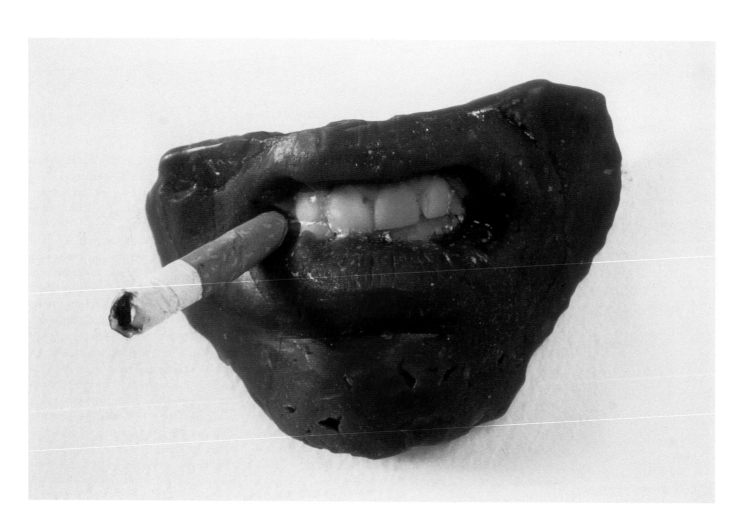

ing the nose and ears, the wheel hubs, the bobble at the top of the hat, and the handles of the wheelbarrow. Sometimes they ran across it, blurring the detail. Because of the gnome context, the activity of coursing, as opposed to the aesthetic effect it achieved, suggested amateur model-making or other craft-activities: a world of matchstick galleons, small-time and low-brow.

The slightly twisted class theme (with its nostalgic inflection) ran throughout the show, and the cigarette theme never let up either. In the press material I'd received from Lucas's gallery, entire interviews were dedicated to it. She'd given up smoking and started again; she thought cigarettes were necessary if you were an artist because they gave you a space in which to think; she thought they were disgusting and they killed you. There was no cigarette cliché left unturned; but in her work she uses cigarettes in a lot of different ways, ranging from the expected – a prop in a photo – to the surprising – using them almost as mosaic tesserae.

The last work I looked at featured smoking, as the first had. It was called *Where Does It All End?* 1994–5 (fig.12). A cast in wax of the lower part of Lucas's face – chin, mouth, and the beginning of her cheeks – it had half a real Marlboro Light fitted neatly in a drilled hole on one side of a neat row of teeth. The gums were the same liverish dull red-brown as the lips, and so was the rest of the face. The whole thing was a nondescript shape, surprisingly small, only about four inches across. As I walked away it became a smaller and smaller blip on the large white wall, like a stain waiting to be wiped, and I thought about the last time I was at Lucas's house. For this book I interviewed her several times (all the quotations below are taken from these discussions). I always smiled at the way the front door was collaged with lurid flyers advertising pizza delivery services – they're so annoying and here she was sending them back as art, right at the point of delivery. In the last interview she said she was convinced art had to be 'light' today; she couldn't see how you could avoid that.

EATING A BANANA [13]
from SELF PORTRAITS 1990–1998
1999
Iris print on Somerset Velvet paper
57.5 x 54.8 (22 ⁵/₈ x 21 ⁵/₈)
Tate

NOBBY 2000 [14]
Plastic garden gnome, cigarettes
70 x 34 x 68.5 (27 ¹/₂ x 13 ³/₈ x 27)
Private Collection, London

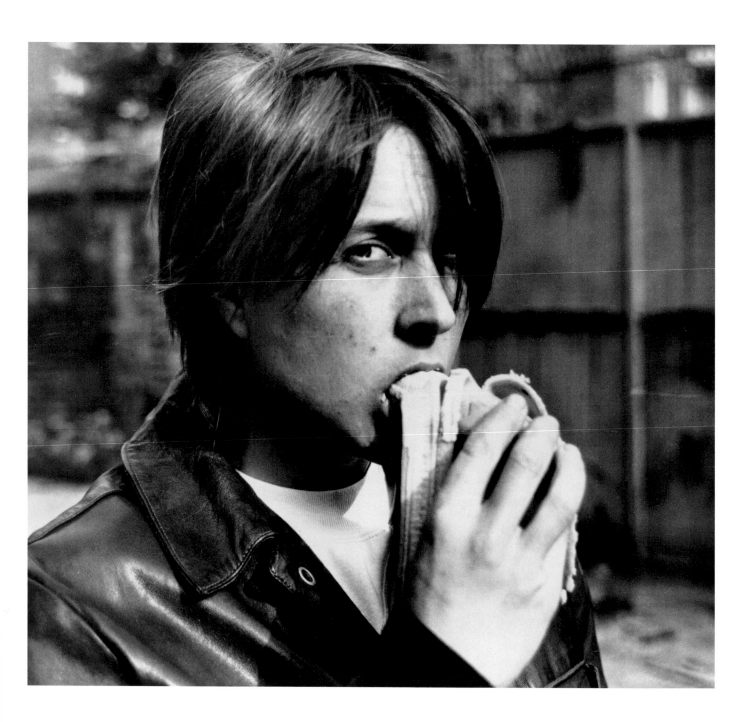

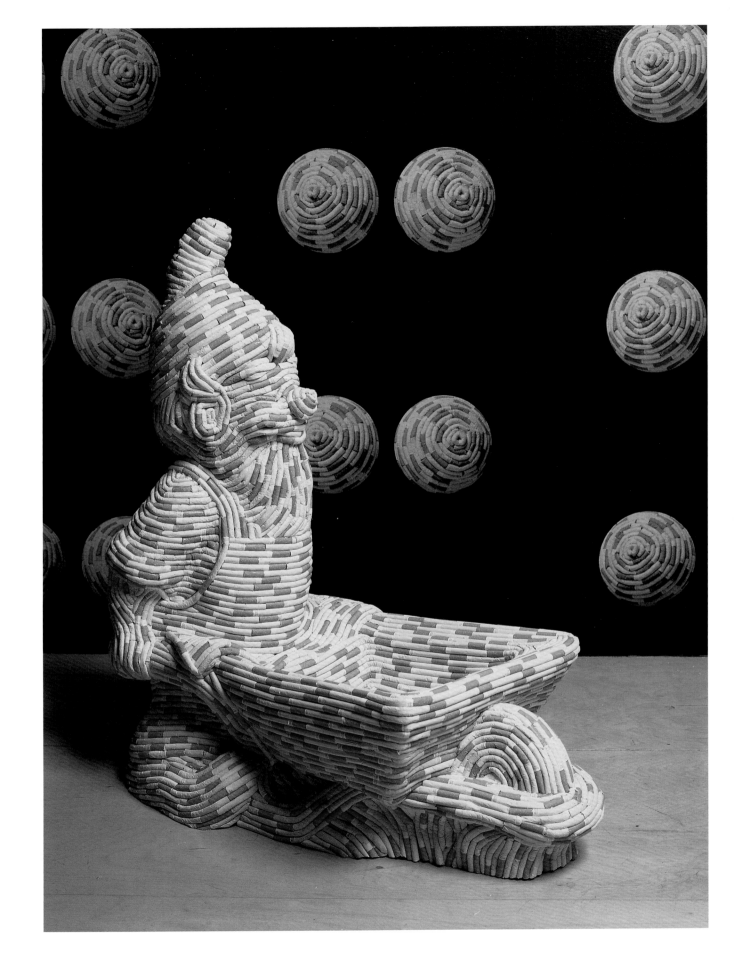

One of the reasons I was interested in the feminine was that I wasn't successful. I lived with [the artist] Gary Hume. I was reading a lot of feminist writings and that led to arguments, because I was angry with him for being so successful. And not just him, but lots of other people, most of my good friends – but him, being my nearest and dearest, he really got the worst of it. I don't get so aggressive when I'm drunk now – but I used to come home furious from openings and fancy dinners, and he'd get the brunt of all that anger.

'Penis Nailed to a Board' was the title of Lucas's first solo show, held in 1992 when she was twenty-nine, at a now-defunct gallery in South London called City Racing (named after its location, a former betting shop). It's a key event because it made her famous and it introduced her main theme: representations of gender – not what it means to be male or female, but how people come up with symbols that represent gender difference. These tend to be base and crude. This is a way of looking at things that is informed by post-Freudian social theory and by feminism. But the exhibition didn't seem particularly theoretical, or even particularly feminist. It seemed very alert to modern life, especially the sleaziness of it. Also, visitors were impressed by Lucas's staging of brute, unsubtle content, which suggested at once that very little work had been done and also that no incredibly sophisticated ideas were being offered to make up for the lack of any obvious skill. This was a joke the art audience hadn't heard for a while, so it seemed strangely fresh. In fact, the show did have ideas but they were so starkly presented it was hard to recognise them as such. The individual works were symbols of modern attitudes to sex and gender. You could say the objects had two codes – a popular one and also a critical one that comes from feminism. The unifying element was a kind of crude, on-the-lap handicraft that disarmed you – it made you stare, while leaving you confused about what you were staring at. Even the works involving huge Xeroxed copies of newspapers had a hand-made aspect, since a relatively unsophisticated process was used, whereby a single sheet was blown up into sixteen parts, which then had to be glued together.

The news scandal that inspired the show was from the previous year. The complete headline in the *Sunday Sport* reads: 'Penis nailed to a board in sex game!' It was a big story, by no means confined to the tabloids, involving a group of men who got off on sexually torturing each other, but who'd been had up in court for

offending public morals. The story in the *Sport* is disgusting but hard to ignore – one of the pull-quotes reads: 'Some had their testicles sandpapered, court hears.' Lucas presents the whole page as a kind of board game, a play on two of the words of the headline. There's a box and a box-lid. Within the upturned lid lies the page – but where there was a row of mug-shots of the accused, there are now empty spaces – and within the box are all the faces, mounted on little flat wooden rectangles, making up the pieces of the 'game'.

Apart from cutting it up and arranging it three-dimensionally, I didn't do much to it. Previously I did introduce things when I worked with newspapers – I'd try and paint on them, stuff like that. And it just seemed, in the end, better to not do that. It was better to stick with the identity of the thing. Anything else you do puts a slant on it, somehow, which I realised I didn't want.

I thought the original story was about the whole ambiguity of whether it was OK to consent to what you want to consent to. And the work I made out of it was about the sex thing at the time generally – all that stuff in all the papers, and just the whole level of kinky sex. At the time it seemed a new thing to have it talked about in that way, in public.

When I was a kid we used to get the Daily Mirror *every day. It came through the letterbox. And there was always a topless image in there somewhere. I'd sort of look at it but if my Dad or Mum passed by I'd probably turn the page or something – so I was aware of that element of it being a very different thing between looking at that stuff privately and making it public.*

City Racing was a modest, self-help operation run by artists. Lucas was offered a show as part of the gallery's programme of exhibiting work by little-known figures. She was an outsider-insider. She'd completed a BA in Fine Art at Goldsmiths College, London, four years previously but had no success since. A student work was included in the exhibition 'Freeze' in 1988, organised by Damien Hirst, but it was ignored. In fact, it was one of the few works in 'Freeze' that failed to sell.

After 'Freeze' I decided to stop making art altogether. Then I started tinkering around with bits and pieces, without the pressure of trying to keep up with everyone else, because I'd already given up. And I decided to just enjoy it, but the enjoyment was definitely aggressive enjoyment.

PENIS NAILED TO A BOARD 1991 [15]
Card, collaged newsprint
Two parts, each 5 x 30 x 30 (2 x 11 3/4 x 11 3/4)
Eileen and Michael Cohen, New York

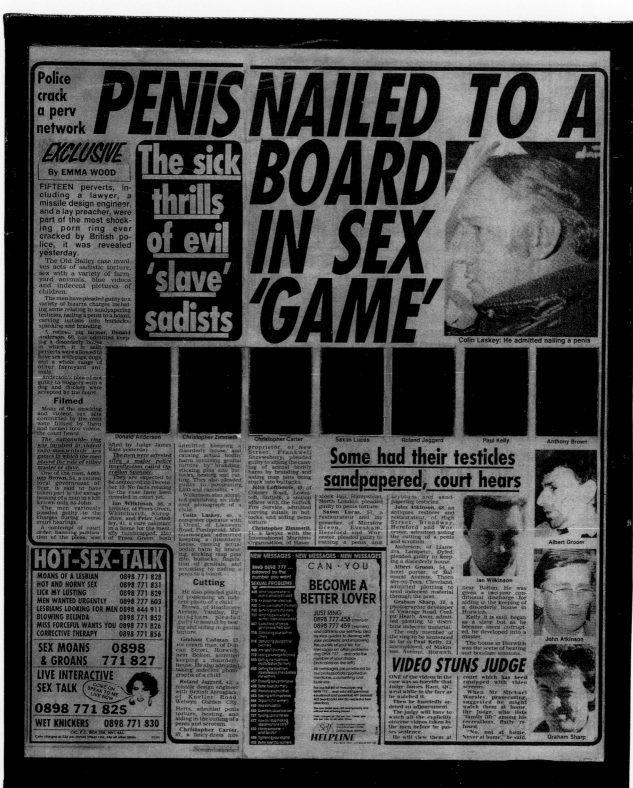

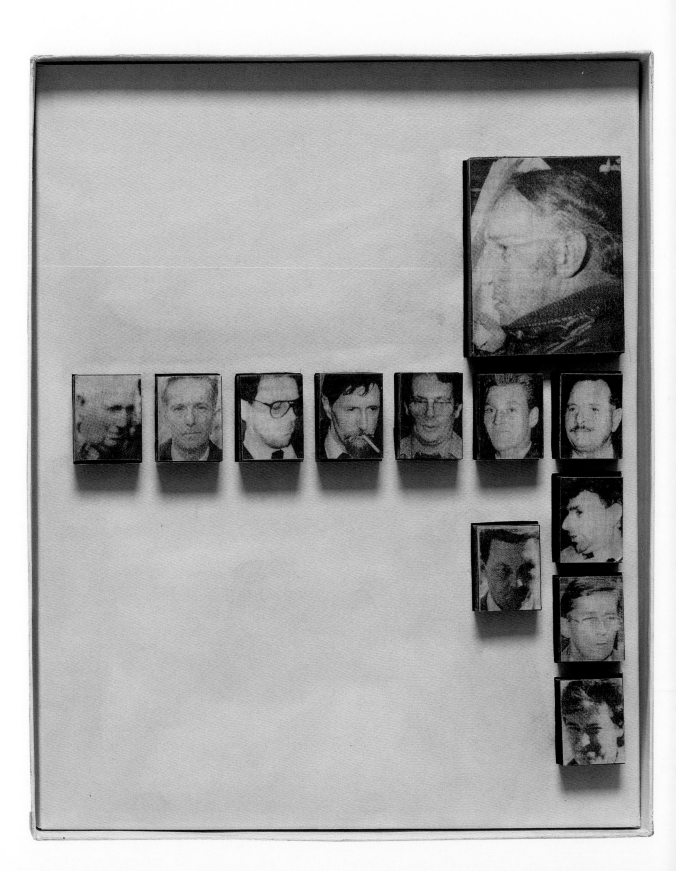

The show was considered by many to be a single installation, perhaps because all the works had the same basic theme. In 1992 nihilistic bleak idiotic sex, as opposed to solemnly theorised issues of sexuality, was new to Young British Art (the acronym 'YBA' had already been coined by journalists following Charles Saatchi's first survey show of that name held the same year at his private gallery). But it certainly wasn't new to the media. Much of the show's content had already been seen as Lucas presented it here – more or less untransformed – in the form of news-paper stories.

It's not just the Sport. *It's all the stuff you see on posters and in advertising; the way in which sexuality is used around you all the time; and when you call it 'acceptable' and when you don't. I deliberately steered clear of material or imagery that was unambigu-ously pornographic – it was the common currency of the* Sport *that was important; the fact that it only cost 25p and that everyone knew about it. But at the same time I was aware that once you start using that sexual stuff, people are going to judge it much more severely than the* Sport *using it. Or they're going to think you've got an angle on it, in some way: either that you're perpetuating the whole thing, or that you're sort of very angry about the whole thing. The fact that I wasn't entirely sure how I felt about it was part of my decision to use it. I thought the important thing was not to be moralistic, not to tell others what to think.*

Another work in the show was an untitled collage made up from cut-out photos of the tip of a penis laid over a shot of vegetable soup (fig.16). The cut-out penises floated in the daft, horrible goo. I thought it might be a modern riff on the Surrealist cliché of a sea of eyes, and on Freudian symbolism in Surrealist art gener-ally. But there was something about the crude anti-finesse of its making that chal-lenged an art-history reading and simply returned you to the fact of what was there. It had an abruptness and arbitrariness that you might expect would work against it but which in fact made it powerful.

SOUP 1989 [16]
C-type print, photocollage on panel
152.5 x 122 (60 x 48)
Helen Harrington Marden, New York

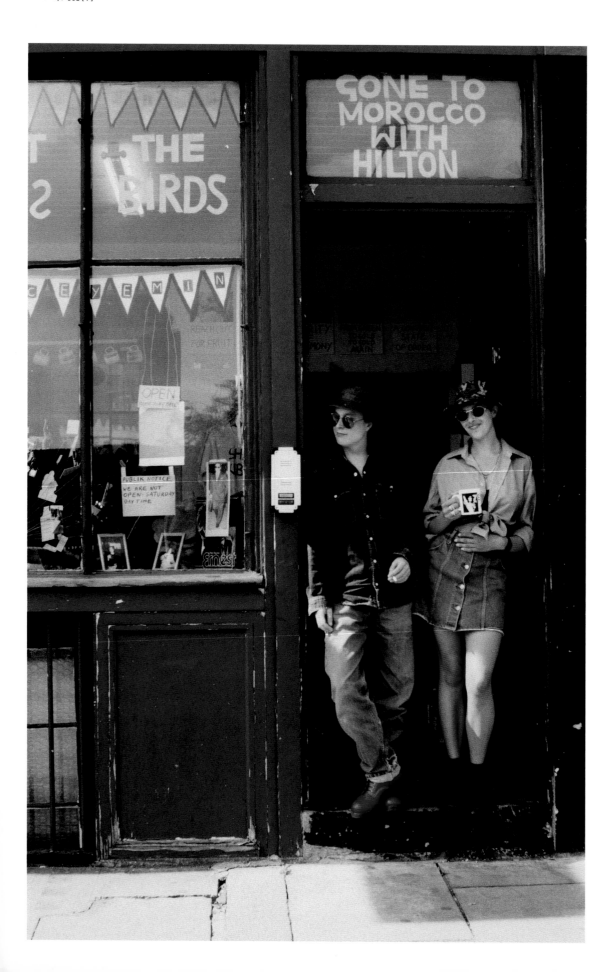

2

When Lucas said art had to be 'light' nowadays, I took her meaning to be that it had to be accessible. One thing that is accessible to everyone is sex, at least as a notion. And that's what seemed to be the driving force of the little shop on Bethnal Green Road that Lucas ran, together with her friend and fellow artist Tracey Emin, for a six-month period during 1993 (figs.17, 18). They sold T-shirts with hand-painted slogans on them reading: 'I'm so fucky', 'Have you wanked over me yet?', and 'Complete Arsehole'. A variation on the last one was 'Fucking useless'. So it was a certain kind of titillation the shop offered: sexual but also hopeless, destructive, foolish, funny, sad.

If you went there you'd be met by a pair of smiling intelligent women who were both eager to be friendly. At the same time it was clear as soon as you stepped in the door that nothing else about the shop was positive or pleasant, except the atmosphere of creative energy – and this energy was all about rudeness. There was a kind of sneering to it, a punk-like self-contempt, combined with world-contempt, as well as a punky drive to be always drawing attention to the hateful matter at hand and not just getting on with it quietly or in a solitary way.

When they held a party at the shop once, a sign over the door announced 'THE BIRDS'. Cackling drunkenly, their eyes rolling round in their heads, they told a TV crew that they themselves were 'the birds'. Another time they sent a publicity card showing a photo of the pair of them standing in the shop's door, holding some big melons, with a caption on the back reading, 'BIG MELONS'. Once I bought a hanging mobile there for £50 made of cut-out photos of Lucas sitting in a chair, which were suspended on cotton threads from a wire frame. As I wrote later in a book, I wasn't sure if this was expensive or cheap, but it was certainly one of the most expensive things on offer.

An ashtray with a photo of Damien Hirst amateur-ishly glued in the base, looking up to receive your fag butt, cost £5, which anyone might have thought was overpriced.

The shop seemed to be a manifestation of delayed adolescent energy (Lucas had just turned thirty) against a particular social and artistic background. Although there were no exhibitions as such, it was a parody of a contemporary gallery: galleries were still 1980s-corporate-style, white square lifeless and pretentious, run by intimidating zombies (as they mostly still are today); whereas nothing in the shop had a power look. Everything was tacky and small-time. There were slightly altered or decorated key rings, mugs, hanging-sculptures, wire penises, and an absurd octopus woman made of stockings and a wig. It was a kind of alternative souvenir shop, selling negative souvenirs of London instead of positive ones, and in the East End instead of the West End.

Claes Oldenburg's *The Store* from the early 1960s might seem a respectable modern art precedent, or Ben Vautier's Fluxus shop, from the 1970s (fig.19). Both seem tedious by comparison, though, because the most striking feature of the Bethnal Green Road shop, besides the obscene things it sold, and its permanent atmosphere of drunkenness and hang-over, was its non-arty unpretentiousness. The only art it referenced without contempt or irony – I remember thinking at the time – was Gilbert & George's early films of themselves being drunk and swearing, which are a slightly uncategorisable kind of art anyway. It was a joke in itself that money had so little meaning in the shop, at a time when society and especially the art world was obsessed by the stuff.

'We just thought, what are we going to do with all this welling, this ball of energy?' – Lucas recalled once in an interview with Gordon Burn. She said her

Sarah Lucas, The Shop, 1993 [18]

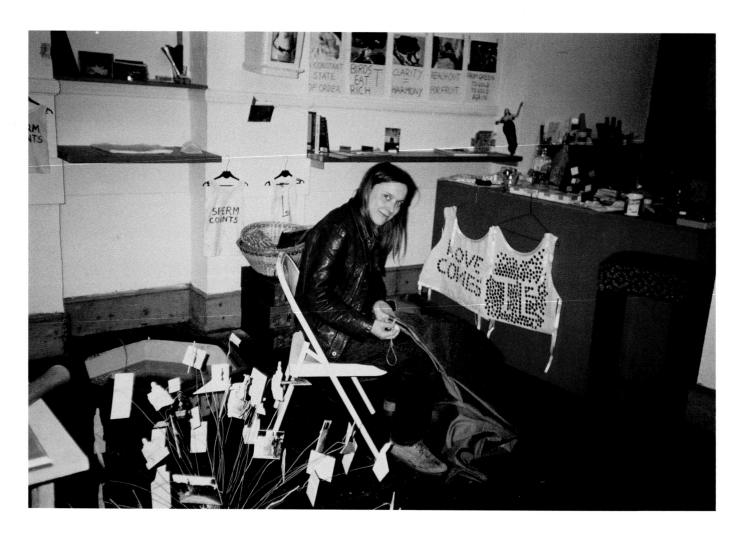

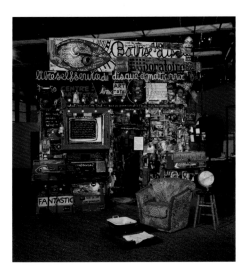

Benjamin Vautier
BEN'S SHOP 1958 [19]
Mixed media
350 x 500 x 350
(137 3/4 x 197 1/2 x 137 3/4)
Installation view, Nice 1958
Pompidou Centre, Paris

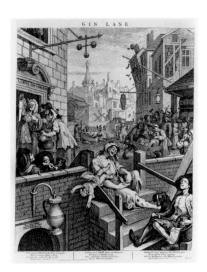

William Hogarth
GIN LANE 1751 [20]
Engraving
Bibliothèque Nationale, Paris

collaboration with Emin, during the period of the shop's existence, was 'practically twenty-four hours a day'. The relationship wasn't sexual, but for the audience the fantasy that it might be was part of the excitement of the shop.

The story of the shop has become a routine vehicle for journalists writing about Lucas and Emin to exercise their creativity: soap opera-dramatic, but at the same time art historical, something like an *Eastenders* version of Jackson Pollock's fatal car crash. And there is poignancy at the end of this narrative too, even a hint of death. When it closed down, Emin burned all the remaining nutty wares and put the ashes in her first West End show, at White Cube. In the same gallery, at a later date, Lucas exhibited a concrete bollard called *Headstone for Tracey* 1993 (fig.26. p.37), which she'd had inscribed with the phrase, 'Fuck me while I'm sleeping'.

In some ways Lucas belongs within a Hogarthian stream of art. Hogarth invented a certain type of English narrative composition, where there's always a clear and interesting story with which anyone can identify, and usually a pronounced element of moral squalor (fig.20). With Hogarth the moral lesson is commonsensical: drink will do you in, debauchery leads to madness, etc. Although Lucas is a moralist too, she preaches a different kind of morality – a late-century post-Freudian morality of the self and gender, and political relativism, and so on, mixed with a conflicting mid-century modernist existential morality about authenticity, and being 'real'. There is no narrative content in a Hogarthian sense: when she arranges old sofas and beer cans, toilets, tables, mattresses, buckets and kebabs to stand for the body, they also seem to be merely themselves. But there is a kind of narrative substitute, in that the viewer tends to make one up out of representational but non-narra-

tive fragments. In Hogarth there is a rich visual element that comes from the culture of 'painterly' painting, from Titian through Mannerism, Baroque and Rococo, that makes his social scenes much more than a series of cartoons. It might be said that with Lucas the corresponding element – which deepens the effect – is her sense of the visual richness of surfaces and textures, however 'low' the objects she uses might be.

In the five years between leaving Goldsmiths and having her first show, Lucas discovered the feminist author, Andrea Dworkin, who writes about issues of pornography and male violence against women.

I started off on Andrea Dworkin, and that led me on to other feminists, Jacqueline Rose and Juliet Mitchell, which led me more into psychoanalysis, and Freud and Lacan. And I got interested in linguistics. If you're making an artwork, a lot of things fall into place at a certain moment, and there's something very simultaneous about everything. And one of the ideas I got interested in from linguistics was that meaning is present in language in a kind of simultaneous way – for instance, you have to use words to explain other words. But you have to understand a lot already to be able to use the language. And nobody learned the language out of a dictionary.

It might seem a peculiar leap to go from this kind of thing to the stark futility of the 'Penis Nailed to a Board' exhibition. On the other hand, you could imagine that futility has a certain role in Lucas's art. You could see the works in this exhibition as jokey (because literal) embodiments of notions that come from a feminist reading of art history. *Still Life* 1992 (fig.21), one of the works exhibited, was an upside-down bicycle with a length of timber laid along the wheels, supporting a row of little snapshots. These showed an anonymous naked male holding suggestive marrows and cucumbers, and so on, in various

STILL LIFE 1992 [21]
Bicycle, wood, card, C-type print
photographs
115 x 140 x 56 (45 ¼ x 55 ⅛ x 22)
The artist and Sadie Coles HQ,
London

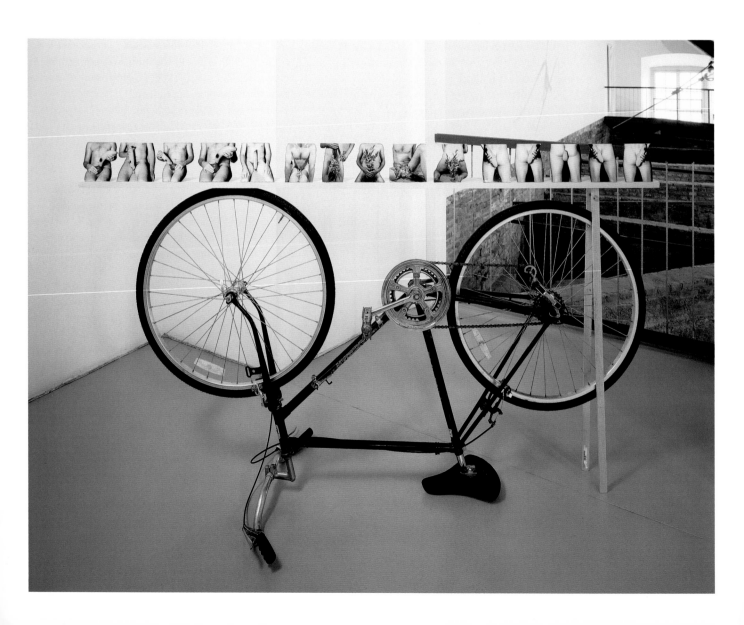

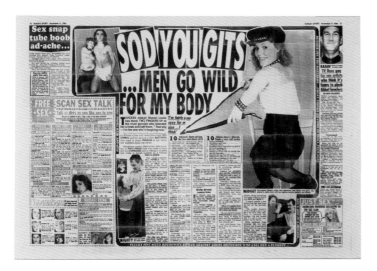

SOD YOU GITS 1990 [22]
Photocopy on paper
216 × 315 (85 × 124)
The Saatchi Gallery, London

lewd positions. Maybe the bike's upside-down-ness is the male gaze turned on its head – which goes with Lucas's humorous deconstruction of the awful phrase 'the town bike: everyone's had a ride'.

Dworkin constantly invokes the 'real' as opposed to the 'abstract' – 'real violence' happening to 'real women'. She says that in pornography 'everything has a meaning'. Within this exhibition of sex and feminism, where the feminism wasn't as immediately noticeable as the sex, it was easy to imagine the bike having sexual connotations, or anything at all having them. But even if you weren't on full signifier alert, you could smile at the way the amateur snaps presented an alternative-universe version of the glossy advertising world, where what should be seamless or invisible is comically noticeable instead.

The photos of a bloke – Gary Hume – started out as photos of myself. I switched to using him because using a woman looked so much more like advertising. The way the fruit looks, which is very beautiful in a way, and the colours and the strikingness – they just turned it into something else, which wasn't what I wanted. But with a bloke they made sense.

I see all Lucas's explanations for her use of materials, and the reasons she gives for particular arrangements of materials, as suggesting that she has an idea of a clichéd representation in mind, a feel for what the norm is – but that she wants to produce a surprise instead.

Originally, when I did those photos in Still Life, *I put them on the mantelpiece at home, and I thought, 'Well, that's OK' – because you've always got to decide why something is a certain size. So the fact that they were a particular size and were standing up like a conventional picture, made it ideal to put them on a mantelpiece. But when it came to doing the City Racing show, I thought if I built a plinth, or even if I built a mantelpiece, it would be formal in a way that might take the lightness and the*

humour out of the photos. That's when the idea of the bike came in. It was just knocking around. I could have put them on something else but I wound up putting them on a bike because it was handy. The bike's obviously very lively and sort of busy as an object, and that left all the life in the photos.

The objects in *Still Life* are down to earth and domestic. They look ahead to Lucas's sculptures involving food. It tells you something about male power that you can turn a table and some food – the whole context of woman as provider – into sexual symbols. Lucas's staging of this kind of thing always has an air of desperation or wretchedness about it, but not necessarily personal suffering. Critical interpretation or apology for her work often seems to make its feminism seem evangelical or furious, whereas what is usually striking about the work is the combination of hot and cool.

A typical explanation of Lucas (from a book by the critic Sarah Kent, written for the Saatchi Collection) is that she is 'an aesthetic terrorist pillaging mainstream culture', and that she 'acts as a mirror, monitoring the sexism and misogyny routinely found there'. But in her interviews Lucas says the reason she uses 'sexist attitudes' is because 'they're there' and she gets 'strength' from them for her work. Presumably they're strong because they're real and not abstract, as Dworkin points out (but with a different aim in mind from making art out of them). At other times Lucas doesn't even bother to talk like a feminist at all. Her curiosity about how the language of sex and gender is formed and used has an air of reasoned detachment.

If I look at the Sport *I seem to be able to think it's a bit gruesome – more so on some days than others – and also it's quite funny. I don't think I have a problem with having more than one view about it at once. I don't suppose many people do.*

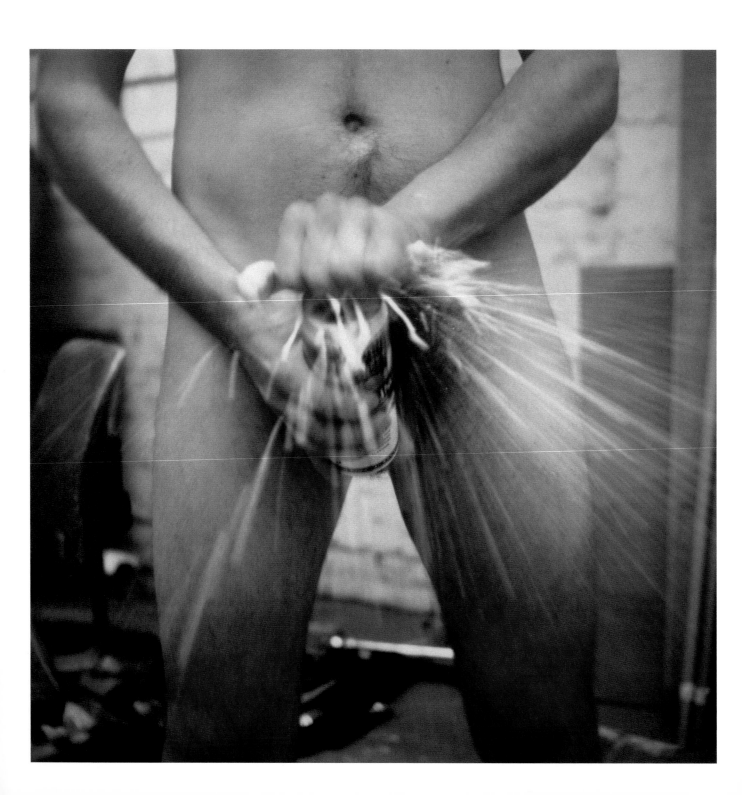

GET OFF YOUR HORSE AND DRINK
YOUR MILK 1995 [24]
C-type print on aluminium
91.4 x 91.4 (36 x 36)
The artist and Sadie Coles HQ,
London

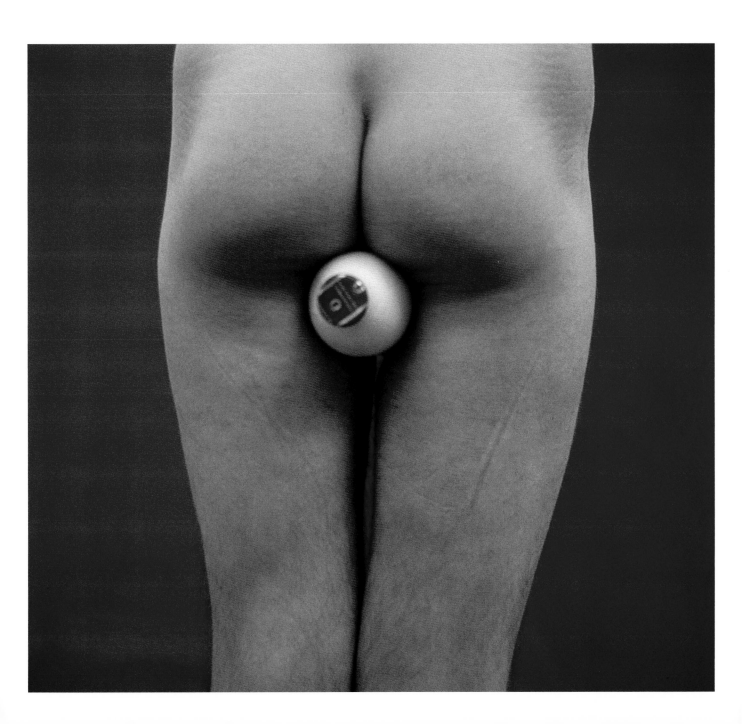

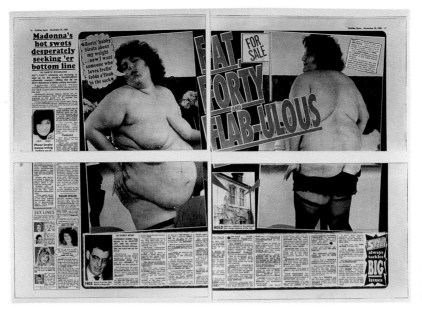

FAT, FORTY AND FLABULOUS 1991 [25]
Black and white photograph
Four parts, each 30.5 x 40.5 (12 x 16)
Tate

One of the *Sport* spreads features the headline, 'Fat, Forty and Flab-ulous!' (fig.25) You can get the point of these spreads, with their images of lolling, grinning nudity – an updating of the nude in art, bringing something sacred and important down to a level of baseness – without actually reading any of the news stories. But the story in this case is about a man who wanted to sell his wife because she was too fat. Reg Morris was so 'naffed off' with his twenty-five-stone wife (who is, of course, sexually 'insatiable' as well as fat) that he decides to put her up for auction along with their terraced house. His ad for the double sale includes the gag: 'An old-fashioned facade in need of redecorating – like a trowel load of make-up!' The article is illustrated by two shots of the 'marshmallow mound missus', from the front and from the rear, naked except for black stockings.

In interviews Lucas says she used the spread because she found it 'quite horny', which doesn't fit with being on the look-out for misogyny, like the fire brigade on the look-out for fires. On the other hand it's a complicated response, since it forces you to reflect on what it might mean for a woman to come out with a statement like that, in public, about the use of an image of another woman – especially loaded when it's in the context of the grotesque.

An old-fashioned moralist interested in art – for example, John Berger – might say, 'Well, there may be elements of the unexpected to Lucas's story but in the future it will be seen that all she really did was respond to the decadence of the culture to which she belongs. Her talent will only reveal negatively but unusually vividly the nature and extent of that decadence.' (This is in fact a paraphrase of the criticism Berger made of Jackson Pollock, writing in 1951.) But if her work can be accused of decadence, it's decadence with a new twist. Of course it's hard to be an artist and escape your own time, but actually Lucas does have a complicated relationship with now. The secondhand-shop objects she makes into art tend to suggest the 'everyday' of a slightly earlier era, working-class culture of the 1950s and 1960s. As to the charge of decadence, there is a moral issue at the heart of what she does. Her work is preoccupied with common representations of gender difference, and with the way such representations might seem to operate in rarefied art. And in repeatedly turning over this ground, she shows her audience something about the crudeness of their beliefs about gender – so there is a political point in questioning what it means for a woman to be rude.

HEADSTONE FOR TRACEY 1994 [26]
Cast concrete
66 x 25 x 25 (26 x 9 7/8 x 9 7/8)
Robert Branston, San Francisco

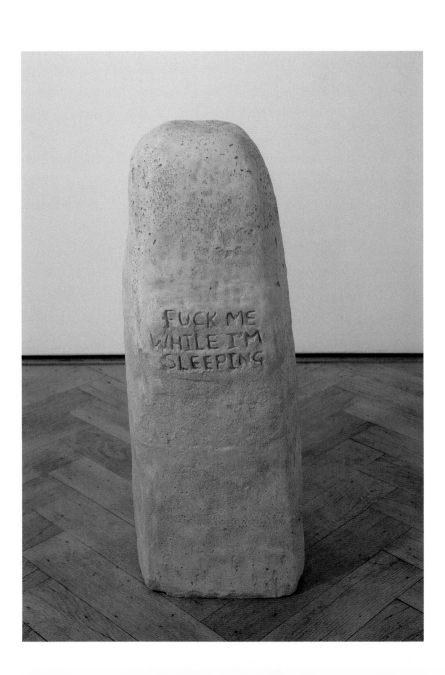

This work consists of a table, the objects named in the title, and a photo of the objects, which stands on the table. The table might be a body and the objects might be breasts and a vagina. The photo could be taken as a kind of face, since it stands at the opposite end of the table to the kebab – it recalls Magritte's famous painting of a woman's face, which also doubles as a naked female body (*The Rape*, 1929, fig.28).

I can't remember why, but I decided to do something on a table. I suppose because it's a handy object. I had all sorts of crappy things. I'd had a dead mouse knocking about for some time. There was going to be an egg sandwich, a whole egg between two slices of bread – this was a response to those stone eggs on people's mantelpieces, which I hate because of their air of phoney significance. I wanted a kind of world of things going on – from globes to sandwiches to the mouse hanging off the table on a string. And out of all that the idea just suddenly occurred to have two fried eggs and a kebab on the table. One minute you're thinking about doing something on a table, and the next minute the table's completely integral to the whole thing. It was one of those flashes of inspiration. I had it lying in bed and I knew it was right. It brought the table into play as a part of the work, so it kind of solved everything: why the table was there – it answered its own question. But I wouldn't have arrived at that idea if I hadn't had a whole table top of stuff in mind in the first place.

It makes me laugh because people say, 'What? You got two thousand quid for two fried eggs and a kebab?' But some of those people actually don't see the table as part of it. They really do think it's only two fried eggs and a kebab.

The work has become an icon of 1990s Young British Art. In some ways it conforms to a cliché of YBA attitude: 'Yes, this too can be art' – invariably referring to something that seems annoying and slight. In fact the content of *Two Fried Eggs and a Kebab* is about a transformation that takes place in the mind, which is obvious and subtle at the same time: one thing turns into another, while still being itself. But neither is very much.

There is something distinctive about the work's double meaning. It's neither particularly demanding nor particularly entertaining. Old-fashioned British smuttiness, like the jokes on seaside-postcards and in *Carry On* films, is made more extreme but at the same time countered by an odd, incongruous avant-garde minimalism – which creates a drained look, a complete lack of gloss.

If you put two fried eggs on a table – two real fried eggs – you might think, 'Well, they'd look better on this table – in terms of taking it like a picture – if they were three times the size of fried eggs'. But fried eggs aren't three times the size, if you're going to use real ones. So you accept that. If you were doing a painting you'd have complete free rein over how big you made the egg. You'd know it could be any size and it'd still be a fried egg. But if I was going to have it any size I'd have to make it not a real egg, and that would change the whole thing.

In my mind I made the egg bigger – I thought, 'Oh yes, an egg's beautiful, it's white and it's yellow'. But then when I saw it, it wasn't anywhere near as startlingly graphic as I imagined it would be, even in just a colour way.

The work has colour, but the colour is knocked-back. And it has elegance, although it's a pared-back, minimal elegance. Picasso does something witty and fast thinking with shapes, signs, associations and connections, which is like the thing Lucas does. His bull's head made out of a bicycle's handlebars and saddle (fig.27) is a precedent for *Two Fried Eggs and a Kebab* – as well as a principal target for its attack, insofar as *Two Fried Eggs and a Kebab* is a joke on the masculinity of art, as well as just a joke on masculinity.

Lucas's work was made for a show in Soho, in a shop, a temporary space made available to her at the same time as her exhibition, 'Penis Nailed to a Board'. There were two rooms: a small back room plus a front room (also not very big), which was the shop part. *Two Fried Eggs and a Kebab* was in here, with lighting provided by two cheap photographic lamps.

I had all the paraphernalia for the frying, the little Primus stove, the pan and so on. It smelt of frying. I was quite happy to go there every morning, buy a kebab and fry up the eggs. It seemed part of the installation. It never crossed my mind that someone would buy it.

I was thinking about reacting to what was directly around me, rather than what was in the art world or in art history. I think a lot of those ideas of what came before only come up afterwards – as with the example of Magritte. Now I can't take the Magritte idea out of the work, because the photograph is part of the work. But it wasn't the foremost thing in my mind.

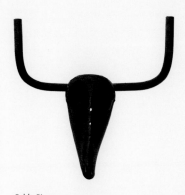

Pablo Picasso
BULL'S HEAD 1942 [27]
Bicycle handlebars and leather bicycle seat
33.3 × 43.5 × 19 (13 1/8 × 17 1/8 × 7 1/2)
Musée Picasso, Paris

The eggs congeal and the meat putrefies. Rotting-food art is a cliché of the contemporary avant garde. In the 1980s and early 1990s, Helen Chadwick used fruit and vegetables to allude in a metaphorical or poetic way to all sorts of aspects of the feminine: the shape of genitalia, female fecundity, sexual exchange, and so on. Foodstuff in Chadwick's art often went with images of her naked body. Food went with a less emotionally distanced and more freaked-out kind of nudity in performances of the 1960s and 1970s in America and Europe. In New York, Carolee Schneemann rolled naked in supermarket chickens and sausages. And in Vienna members of the Aktionismus group, led by Hermann Nitsch and Otto Muehl, slaughtered farm animals in front of audiences, and writhed in the blood, in orgiastic happenings styled after fantasies of pagan rituals. But *Two Fried Eggs and a Kebab* is different from any of these precedents, because it is not soppy, solemn or frenzied, but dry, witty, clever and sly.

Everyone's familiar with a fried egg. And everyone's used to anthropomorphising things.

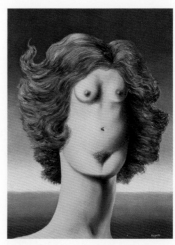

René Magritte
THE RAPE 1934 [28]
Oil on canvas
73.4 54.6 (28 7/8 x 21 1/2)
The Menil Collection, Houston

TWO FRIED EGGS AND A KEBAB 1992 [29]
Table, photo, fried eggs, kebab
151 x 89.5 x 102 (59 ½ x 35 ¼ x 40 ⅛)
The Saatchi Gallery, London

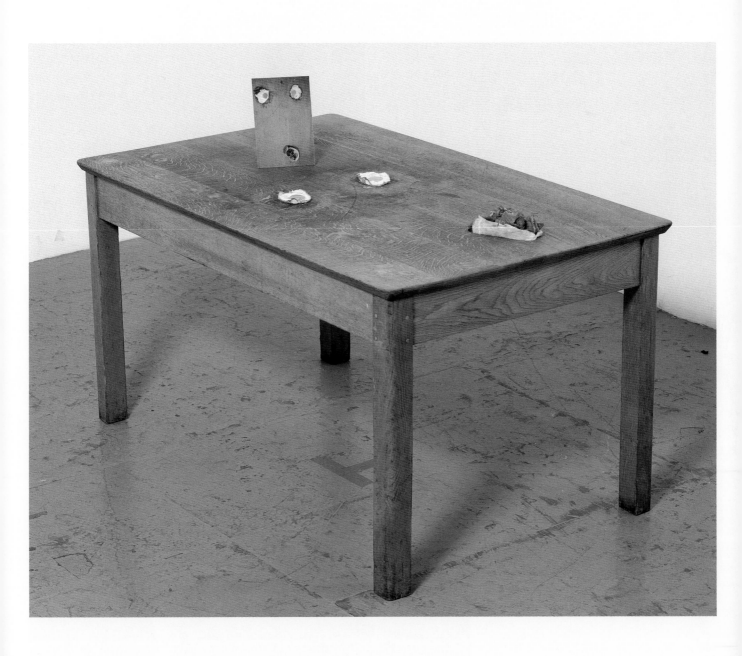

YOU KNOW WHAT 1998 [30]
Plaster, cigarette and table
85.1 x 78.7 x 94 (33 1/2 x 31 x 37)
The Saatchi Gallery, London

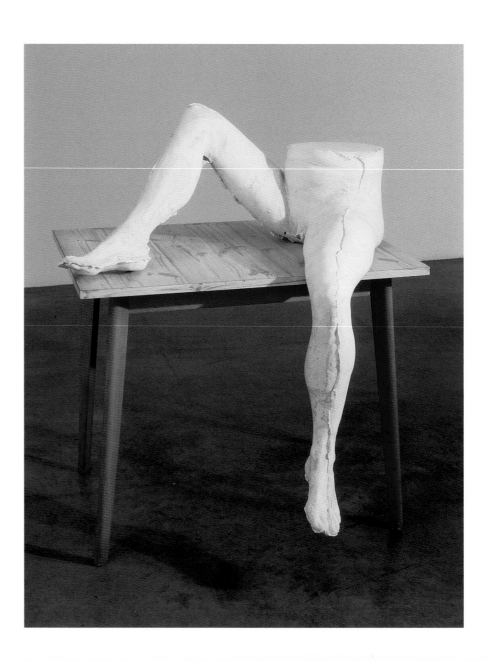

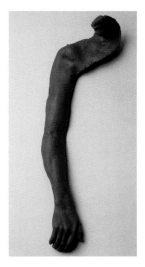

Bruce Nauman
FROM HAND TO MOUTH 1967 [31]
Wax over cloth
71.1 x 26.4 x 11.1 (28 x 10 3/8 x 4 3/8)
Sperone Westwater, New York

3 ART HISTORY

I very rarely look at art.

There's a stage when you're completely open. You don't know anything about art at all, or hardly anything, and you're open to finding out about what's out there, or what it is that you like most. But then when you're a bit further down the line you stop being as open – you haven't got time, really.

Lucas often seems to be digging through traditions of modern art, and recasting them in terms of modern attitudes towards sex and gender. You see allusions to Surrealism, Marcel Duchamp, 1950s Neo-Dadaism and assemblage art, Pop art, Arte Povera, and the stream of 1960s Post-Minimalism and Conceptual art that is about undermining the intellectual authoritarian macho ethos of 1960s Minimal art. This whole stream can be summed up as a type of modern art that deliberately opposes an unreliable idea of reality to a positive idea of formalism or abstraction.

It's not that Lucas is influenced by these movements and figures, in the sense that, say, Picasso is influenced by Goya or by Manet – in some cases she is, in some not. The point is that they're all part of the new broad cultural notion of what art is, and it's this notion that Lucas is looking at.

One figure who appears to relate to the Surrealist/ Conceptual/Post-Minimal grouping, but actually falls outside of it because of his narrative-driven, old-fashioned liberal sentimental moralising, is the influential US assemblage artist, Ed Kienholz. There are echoes of Kienholz in Lucas's sculptures made of old cars – for example, a mechanically pumping Ford Capri in her exhibition 'The Law', in 1997, recalls one of his tableaux involving a couple having sex in the back of a Dodge. But as with her allusions to Surrealism, and to Marcel Duchamp or Jasper Johns, the ethos of the referent is short-circuited or undercut in some way. She is pointed and direct with bodily subjects, which

Duchamp and Johns tend to make into an enigma. She is subtle with material that Kienholz tends to make into melodrama. But some of the humour and formal impact of the original carries over in Lucas's ironic echo – so you're not always sure whose gag it is you're laughing at.

When Lucas photographs herself, the art associations are relatively recent – they include Andy Warhol, Gilbert & George, Cindy Sherman, Jeff Koons. All of these play a game of risking not being seen as profound by bringing vulgar glamour into art. To a degree they all falsify themselves, while the self that Lucas presents in her self-portrait photos is how she is — but at the same time her self portraits rely more on ironic echoes of other art than theirs do. Her self portraits also depend on challenging the viewer to believe that something so apparently casual, under-lit and generally lacking in production values, could be anything at all.

Lucas's sculptures that take the form of body-part casts reference Surrealism, though none are truly Surrealist with a capital S, which means literary, poetic and Freudian, with a touch of revolution – but also slightly respectable: precious, tamed and of the past. Surrealism in visual art has a very concentrated, instantly recognisable tone, while even Lucas's most Surrealist-like works have various tones, including a fuck-you one, which might be a fuck-you to Surrealism.

Lucas's Surrealist not-quite-alikes include *Receptacle of Lurid Things* 1991 (fig.35), her middle finger cast in wax, and *Figleaf in the Ointment* 1991 (fig.34), casts of her armpits, with a dark stubble peppering the white plaster. Put together with a few of her other sculptures, these two could make up a single self portrait. It would be Frankenstein-like because each object seems to sample reality in a different way. The ensemble might include *Self*

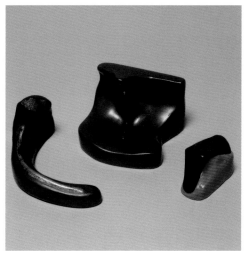

centre: Marcel Duchamp
FEMALE FIGLEAF 1950, cast 1961
(shown with DART OBJECT 1950, cast
1962 and CHASTITY WEDGE 1954, cast
1963) [32]
Bronze
9 x 13.7 x 12.5 (3 1/2 x 5 3/8 x 4 7/8)
Tate

Bruce Nauman
DEVICE FOR A LEFT ARMPIT 1967 [33]
Plaster, copper-coloured paint
35.6 x 17.8 x 25.4 (14 x 7 x 10)
Sperone Westwater, New York

Portrait with Fried Eggs, and her cast of her own crotch – with a real cigarette inserted into a hole drilled into the vagina – titled *You Know What* 1998 (fig.30). You could also add in the cast of her mouth smoking a cigarette – *Where Does It All End?* 1994–5 (fig.12) – her gesturing arms: *Get Hold of This* 1994–5 (figs.2, 42–4); and her real boots with real razor blades in the front soles: *1–123 – 123 – 12 – 12* 1991.

Lucas's *Figleaf in the Ointment* looks very like a little-known work by Marcel Duchamp, *Female Figleaf* 1950 (fig.32), and there is a further echo in the phrasing of Lucas's title. Duchamp's work, apparently a bronze cast of a vulva, now might seem almost conventional, even a bore, because since the 1980s we've been used to seeing a lot of vaguely psychological body-obsessed art featuring body-casts. (And usually involving some sense of something human having been cut off, or separated out in a slightly horrible way.) But previously its status as a modern art object was that of unwelcome outsider, barely making it as an object at all. Lucas's *Figleaf in the Ointment* is a twist or advance on this theme of the unnameable in the context of the feminine; the twist being that Lucas's work is obviously what it is, while it's not at all certain what Duchamp's *Female Figleaf* is. It's often assumed to be mimicking the look of a kind of generalised modern-art sculpture, by Brancusi or Henry Moore, or someone, while actually being something obscene. Also, it's assumed to be a solid cast from a negative – with a typical Duchampian play on 'male' and 'female', as these terms are used in the context of casting in an artist's studio. In fact it isn't a cast at all but a hand-sculpted object made to resemble a cast. And even the bronze is complicated, since it's not really that, but plaster treated to resemble bronze.

Duchamp's statement about wishing to redirect modern art to appeal to the mind rather than the eye is

so well known it's become the stuff of arts TV and Sunday colour supplement waffle and pseudo-debate. The way he actually engages the mind is usually to disturb it pleasurably – to offer it something it perhaps had never realised could be pleasurable. Which is different from the insistence in pure Surrealism on narrowing content down to the wacky stuff that goes on in the mind. Lucas is good at reclaiming head-on this side of Surrealism, which used to be revolutionary and now seems slightly silly – rather than trying to solemn it up with theory-pomp, as today's successful international mainstream body artists tend to do. In being direct, she moves away from Duchamp's intimidating and sometimes slightly repulsive high-mindedness. But she doesn't move totally back into Surrealism, since sex in her work is still at least partly a notion of sexuality informed by a modern feminist intellectual framework. By contrast, for all its current intellectual fashionability, Surrealism can seem tediously porny or else rather routinely Freudian-fetishistic (or basically, corny).

Because they're armpits, Lucas's *Figleaf in the Ointment* recalls Bruce Nauman as well as Duchamp, in particular his 1967 work, *Device for a Left Armpit* (fig.33), where the mould for casting his armpit is presented as a sculpture. A knubbly lump stands on the floor – a smooth bit, inside the top edge of the form, is recognisable as the imprint of an armpit. Casting in this case is seen as a kind of factual record, an objective 'measuring', and a principle of emotional distance is undermined by the presence of something slightly irrational: a nameless shapeless oddity, which, because of 'modern art', is nevertheless readable as some kind of sculpture. However, because Lucas isn't a 1960s Neo-Dadaist, but a populist-feminist Post-modernist, the whole Duchamp-Johns 'device' mystique, where something organic and

FIGLEAF IN THE OINTMENT 1991 [34]
Wax and hair
Lifesize
The Saatchi Gallery, London

flesh-like is made a bit mathematical or mechanical or cerebral – which Nauman ironically taps into with this work – is alien to her, even as something to be ironic about. She minimalises the object even more than Nauman does, with the effect that the joke-reference to 'art' is stripped away and the object is starkly literal. As an object it seems not to care about art, to have nothing mysterious or poetic about it, but still to be richly inexplicable in a way that we somehow still agree is in art's area – to be 'right' but impossible to pin down.

The title of Lucas's *Receptacle of Lurid Things* 1991 (fig.35), her standing-up middle finger on a white plinth, sounds more like Surrealism than the object actually looks. The object has the richness of poetry without a poetic object's expected trappings; a Surrealist version would probably be in a fancy casket, maybe with a bit of black velvet. Instead, the mood is bright, hard and modern. Because it's only small, and it's phallic in order to be deliberately offensive, rather than having something inherently phallic about it that a sophisticated Surrealist or a psychoanalyst could bring out, it seems to be a joke on the whole idea of phallic symbols. Also, because it's standing up rather than lying down, it makes a mini-dramatic formal statement, so it's a joke on Minimalism as well as on Freudianism.

Jasper Johns's cast-wax body fragments are another obvious art-historical referent, both for *Figleaf in the Ointment* and *Receptacle of Lurid Things*. Johns is a sensualist and an intelligent questioner of the sensual realm. He paints a beautiful mark but then does something to it so it becomes a frozen sign. In his early work he often complicates passages of ravishing brushstrokes by introducing some kind of literal human presence: a wax hand or penis, or whole leg, and so on. But with Lucas,

human presence is never fascinatingly arbitrary because it's always the main thing. Plus Johns's and Nauman's sex objects are rarely actually about sex or obscenity, whereas hers hardly ever aren't.

Both Nauman and Johns have early and late careers, becoming quite different artists in their later stages. Lucas still only has a more-or-less early career. She was rougher at first, and did more multiples and editions later, but she doesn't yet have any radical change of theme – which both Johns and Nauman do. Early Nauman is a maker of amusingly lazy objects and videos in which the human body is squarely in the picture, but humanistic content is either so radically advanced it's hard to see it, in which case it wouldn't be very humanistic, or else it isn't there at all. He uses language as a medium, running words and phrases backwards or in circles, or making elongated word-portraits of parts of his body, or his name, which are indecipherable unless you look at the title. Of course having done so, the object becomes redundant – so words (because they're not allowed their normal function) disappoint. With Lucas there may be double meanings but that's what language naturally does anyway, so in her case words are normal. Nauman would be a visual-art Samuel Beckett, if he weren't a proto-slacker. Johns is such a rich painter you can almost believe there might be a corollary between his brushstrokes and Beckett's words. But in any case the humour in Johns and Nauman is intellectual; it really is for those in the know about *Watt* and Wittgenstein. Whereas the humour in Lucas never is; in fact it isn't even really for those in the know about Dworkin and Mitchell; it's for anyone who's ever watched a lot of TV.

In looking at these differences between her art and the art it references, it's possible to get a sense of Lucas as a more human and even conventionally expressive

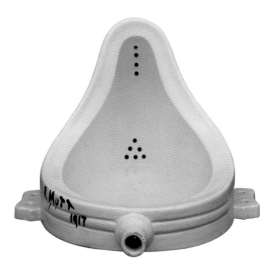

Marcel Duchamp
FOUNTAIN 1917, replica 1964 [36]
Porcelain
36 x 48 x 61 (14 ⅛ x 18 ⅞ x 24)
Tate

artist than is often supposed. Jokes might be present in her work because life is awful and humour is an antidote to misery – and her art might be about linguistics and sign systems, and identity, and so on, but it might also be about depression.

Even though they are both, in fact, well-turned and crafted sculptures, *Receptacle of Lurid Things* and *Figleaf in the Ointment* both seem to engage with another aspect of 1960s Minimalism – the lack of anything much seeming to have been done. One is just a finger and the other is only armpits. For a popular audience, offensive laziness is Minimalism's most glaring feature. As a historical movement Minimalism is more formal than ideas driven. It is often thought to be the result of some kind of perverted 'idea' that has got into art. It connects in the imagination of the new audience for art (which sees Carl Andre's notorious bricks sculpture *Equivalent VIII* 1966, as a kind of voodoo totem of offensiveness) to Conceptual art's magic moment: Duchamp's urinal as art (fig.36).

Toilet humour is never far away with Lucas, but a real toilet only made its first appearance in her work in 1995, with a sculpture called *One Armed Bandits (Mae West)* (fig.61, p.80). In the following year she had a toilet plumbed-in to a gallery in Berlin – *The Great Flood* – and then she re-did it at the ICA in London. Since then, toilets have intermittently reappeared in her exhibitions. They can be 'pure', like the plumbed-in ones: no metaphor or symbolism. This is a kind of joke on avant-garde attitudes: 'Gracious! The naked reality of a toilet!' Or they can be part of a staging of several objects, as in a tableau (*One Armed Bandits* includes a chair, as well as a wanking plaster arm; the toilet is feminine, the chair masculine). Or they can be specially treated in some arty way: cast in transparent resin, or clad with real cigarettes.

Saying that a plumbing fixture might be as elegant as a Brancusi sculpture is part of the deliberate offence of Duchamp's urinal, his breaching of the precincts of hallowed art. Art isn't hallowed in this way any more, so there's no assaulting going on in Lucas's art, at least, not of the old avant-garde sort, where bourgeois uptightness is the enemy and art is freedom.

To some extent dragging art down to a base level is also the point of Francis Bacon's toilets, over which nude men writhe, vomiting or committing suicide in a kind of expressionist parody of Michelangelo. (But with toilets instead of marble pillars, and having a hellish hangover instead of being in a religious heaven or hell.) But Bacon's point is also to be seen as great, like Michelangelo, while at the same time possessing stark modern clarity, like an existentialist – to be saying, 'Yes, this is all we are'. The spirit of *The Old In Out*, Lucas's group of transparent resin toilets, which she first exhibited in 1998, is as much Bacon as it is Duchamp. Vying with the old masters is out of the picture. Clarity about the bleak nature of existence is in, but updated to fit a more modern sensibility. Instead of 1950s existentialism, there's 1990s weightlessness. The toilet's beautification is a joke on baseness. Literal translucency is a joke on clear-sightedness.

Duchamp's urinal, the correct title of which is *Fountain* 1917, has obvious themes of sexuality and obscenity – but also reversals (liquid pouring in instead of shooting out), which relates to a theme of gender bending that recurs often in Duchamp. His frequent use of a feminine alter ego, 'Rrose Sélavy' (a play on *eros c'est la vie*, 'love is life') is just one well-known example (fig.39). Lucas is a gender bender too. On an immediate level her sexiness in photos is not predicated on conventional feminine attributes but is tough and boyish.

The more profound gender bending that runs throughout Lucas's work is where she refuses to take

THE OLD IN OUT 1998 [37]
Installation view, Barbara Gladstone
Gallery, New York 1998

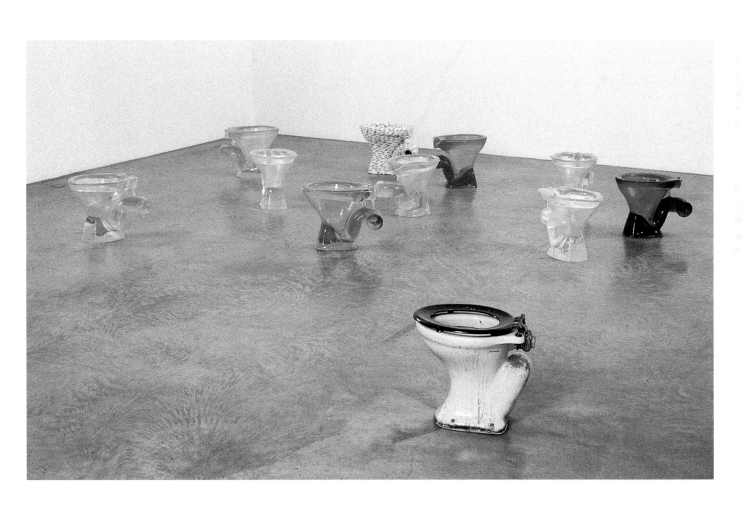

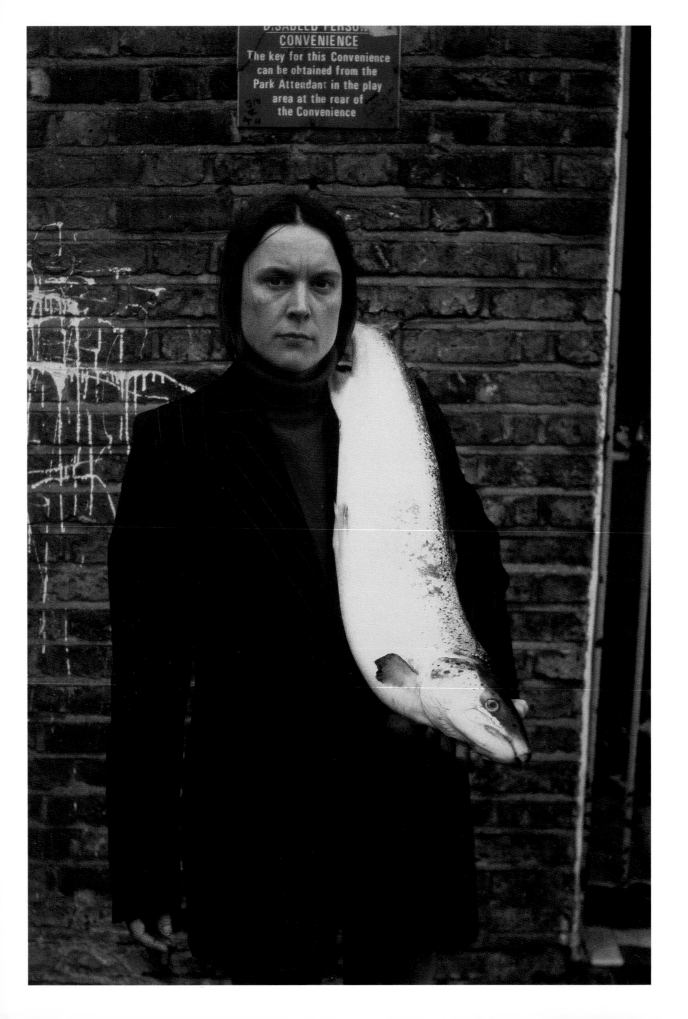

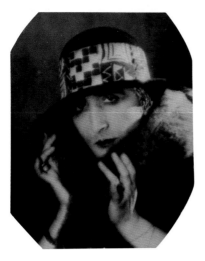

the female position in jokes about gender difference, where the point of the joke is male sexual aggression. On the other hand, all her work has sex as a theme but not eroticism exactly, which is quite different from Duchamp, whose work has eroticism everywhere, but mixed with excruciating cerebralism and mental game-playing.

Lucas's relationship to the German conceptualist, Martin Kippenberger (who died in 1997) is different from the one she has with established art-historical names, or celebrated contemporary figures. He is a cult figure rather than a mainstream figure. Lucas admits to being directly influenced by him, even occasionally looking through a 1998 Taschen publication about him (popular with students) for ideas. They share speediness and flippancy. Kippenberger endlessly re-uses his own ideas, as Lucas does hers, and he does endless eggs and fried eggs (fig.40), as she does. Lucas has a certain way of upping the ante on offensiveness, at the same time accepting that nothing in art can shock anyone anymore. But Kippenberger is insulting on a giddying range of levels – for example, his sensitively realistic pencil drawings of starving Africans, with captions that say things like *Negroes have a longer one – not true!* and *Southern types are more passionate – wrong!* 1983. There are differences, but both artists come out of the same cultural moment: a reaction against supposed 'impossibility': 'What on earth are we going to do now? It's all over!'

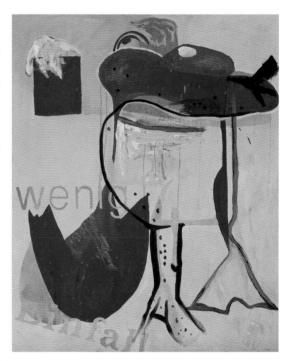

It's kind of a vague thing. Why do you start believing in yourself as an artist? Or believing in anybody else, knowing that's a good artwork and that isn't? For a long time at college I struggled to make anything about which I could say, 'Well I believe this is actually art'.

The first ones I made were in plaster. Then I made one in concrete. It took a long time to get one that was good – that is, no fingers missing. So when I did get one like that, I had a proper re-usable mould made. I didn't have any criteria for the size of the edition, so I adopted snooker-ball colours and made one set of arms for each colour. It was a way to introduce a bit of colour. I first thought of it around the time I made the mouth thing – Where Does It All End? – in 1994. So body parts were on my mind.

When I first saw a version of this work it was a multiple, installed at the Walker Art Center, in Minneapolis, as part of the exhibition 'Brilliant!' in 1996. This was the first major outing in the US for work by the new stars the of the Young British Art wave, preceding 'Sensation' (which was held in London in 1997 and toured to New York in 1999).

I thought the installation was funny because it seemed to mock the most successful and powerful Minimalist artist, Donald Judd, in particular his art production during the 1980s, which consisted of endless editions of workshop-fabricated abstract rectangular sculptures with rococo colouring. No one knew why these works were supposed to be important. And yet they were lapped up. At that time, before the international art-market crashes of 1987 and 1990, there was a particular rush to buy his works on the part of newly built modern art museums in Japan, which subsequently failed to open because of the crashes. Basically Judd's art was seen as a status symbol. I think it's healthy to question a situation of apparent intellectual and aesthetic congestion, where no one seems capable of objectively assessing anything. Also, *Get Hold of This* appeared to comment on issues relating to Judd but which are not his exactly: I thought the macho gesture satirised the whole feminist-reading-of-art-history debate about Minimal art's unacceptable masculinism. Lucas's nutty, absurd obscenity undermined the preciousness, insulated smugness and disguised pseudo-intellectual elitism that had settled in by this time as the accepted moralising tone for theoretical discussion about male power in art.

Perhaps there was also a satire on Young British Art. The gesture was an ambivalent affirmation/denial of the crass cartoon idea of modern and contemporary art that at this time was beginning to form in the public's mind, because of contemporary art's constant exposure. Art was seen as divorced from history, from higher values, from anything aesthetic, dominated by sleazy tabloid values

Cover of catalogue for 'Brilliant!' exhibition
Walker Art Center, Minneapolis, 1996 [41]

and a kind of retro-music-hall daftness. In this surreal modern Punch and Judy show, the leading man is Damien Hirst and his Mr Death black-comedy act. And the songs of the leading ladies, Tracey Emin and Sarah Lucas, are 'I love taking it up the arse!' and 'Come on, if you think you're hard enough!'

These associations, disconnected, contradictory and horrible, were certainly influenced by the context in which I saw the work. The celebrations on the opening night in Minneapolis, put on by the art centre's PR department, included fairground-like stalls where you could have your hair cut in a Princess Di style, and have a photograph taken of your head sticking through a hole in an enlarged British tabloid. Old-fashioned British Bobbies with whistles, as well as Buckingham Palace soldiers in bearskin hats and red uniforms, stood 'guard' and handed out free tins of Altoid Mints (British people are apparently supposed to be as addicted to Altoids as they are to tabloids). The cover of the catalogue showed an enlarged detail from a news photo of the damage done to an area of London by an IRA bomb. Across it ran the headline in a lurid comic-strip flash, 'Brilliant!' (fig.41).

All this, the artists and their dealers, who'd come over from London, professed to be horrified by. But at the same time they were used to it because they'd helped create it, even if they usually preferred solemnity and crassness to be separated – one reserved for the museums and higher ranking international art galleries, and the other for the press. But there was something appropriate and useful about this embarrassing party. It was a travesty of something this art tends to do in ways that can be crass but are often surprisingly subtle and intelligent: to express what we've become and how we see ourselves.

Realism doesn't only mean a realistic depiction, or something like a photo – although in fact the basic unit of this work does have that kind of realism, since it's a straightforward cast. Realism is also about effect and atmosphere, which can vary greatly between different kinds of realism. You could say Lucas is a kitchen-sink realist after Conceptual art. All the meanings through which she's understood and acclaimed come from Conceptual art.

Sex and the body, Lucas's perpetual themes, might seem opposed to Conceptual art, which is an art of ideas not forms. But what 'Conceptualism' means in art nowadays is not dematerialised form but content apprehended in a rather distanced way. That is, distanced from what the subject initially appears to be. The audience has been taught to understand that a typical work by Lucas will

GET HOLD OF THIS 1994–5 [42]
Cast concrete
29.9 x 36.8 x 30.5 (11 3/4 x 14 1/2 x 12)
Museum Boymans van Beuningen, Rotterdam

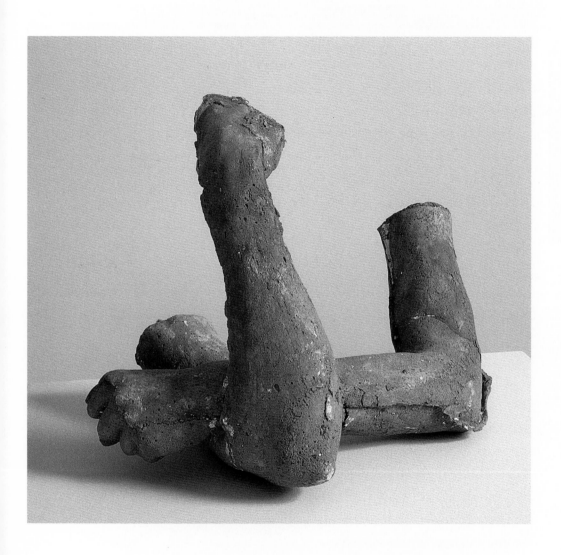

have something standing for something else: objects standing for a body – because nowadays, it is assumed, there's no way to see the body except through the matter of everyday life. A marble sculpture of a nude stands for the body directly. The viewer sees the marble sculpture and assumes he sees an ideal form of a body. The form looks like a woman, only more perfect. When Lucas presents a mattress and a cucumber, they're everyday metaphors for bodily attributes. No one expects them to resemble a body directly in the way a marble sculpture does. But when the objects she presents really do resemble a body, or a part of a body, the rule of distance still applies. The subject of *Get Hold of This* is not Lucas's body. Although the slenderness of the arms, as opposed to them being masculine and muscular, does come into it, the subject is not the arms but the action symbolised by their gesture – the act of fucking. And this itself stands for something else: an insult in international sign language.

Well I suppose it calms down a bit without some irate bloke behind it. Really it's just making something solid out of the gesture – it gives the object a semblance of purpose in being how it is.

But, taking that for granted, it can be admired for its other qualities – what the arms look like, the roughness, the colour, and so on, as well as anything else it might suggest. Bringing in snooker-ball colours adds another layer of machismo, I suppose, at the level of meaning.

The same goes for the repetition. It's light. But then again it seems natural to repeat a cast object, and maybe pragmatic to milk the idea a bit, which is Donald Judd-like.

I suppose there might be a kind of validity in calling my work 'Conceptual', in that it has an awareness of itself as something out there – out in the world. Even being aware of how somebody might respond to it, whether they might be having a laugh or whether it might be embarrassing to someone: I suppose those are considerations outside of the material qualities of the work.

On the other hand when I'm suspicious of this label, 'Conceptual', it's because it usually means, 'Oh there's more to it than you would understand'. Which I don't think helps. Because then people think, 'Well there might be', and that makes them feel confused, rather than trusting their more obvious responses.

GET HOLD OF THIS 1994–5 [43]
Plastic
One from a series of eight (pink)
29.9 x 36.8 x 30.5 (11 3/4 x 14 1/2 x 12)
Private Collection

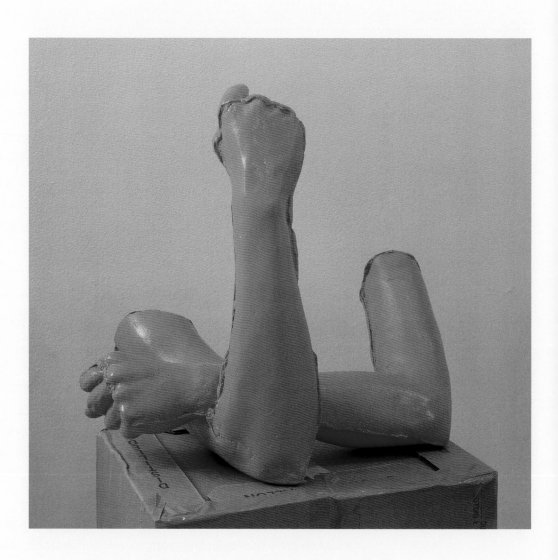

GET HOLD OF THIS 1994–5 [44]
Series of eight
Plastic
Each 29.9 x 36.8 x 30.5 (11 ¾ x 14 ½ x 12)
Installation view at Barbara Gladstone Gallery,
New York, 1995

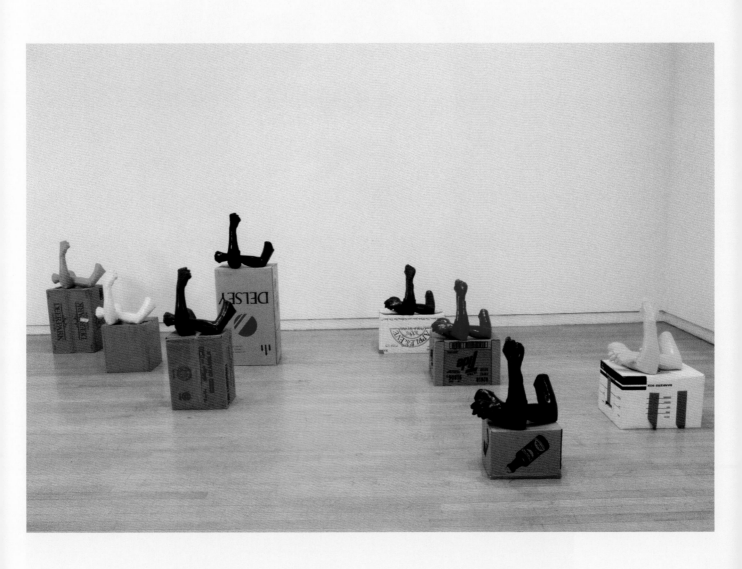

FIGHTING FIRE WITH FIRE [45]
from SELF PORTRAITS 1990–1998
1999
Iris print on Somerset Velvet paper
73 x 51 (28 3/4 x 20 1/8)
Tate

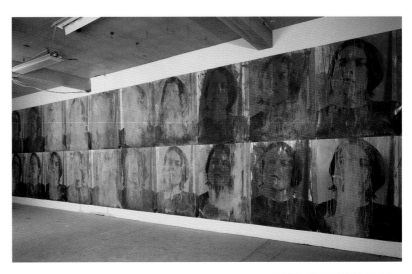

FIGHTING FIRE WITH FIRE 20 PACK
1997 [46]
Installation view, 'The Law', London,
1997

4

ADMIRE OWN SELF

It was sort of an accident, the images-of-me thing. But it did help because it cemented a relationship between myself and the work.

Lucas has a certain look, not mannish but not feminine either. She makes a virtue out of this natural peculiarity, playing with it as something striking in itself, in photos that are otherwise often extremely minimal. They just show her in her everyday clothes, standing there, or sitting, with a prop or two, or nothing. They have a no-style style, with no particular lighting, no gloss or high production values. Compared to her sculptures, which often have a disguised or subtle old-fashioned Modernist aesthetic appeal, they are more genuinely stark or held back.

Her work is very rarely discussed without reference to these photos, as if they hold the key to her whole project. And it's clear from interviews that she encourages this reading.

To me the photos are more mysterious than the sculptures, in terms of knowing where I am. They seem to be so much a matter of taking a stance, but even I find it quite difficult to know why they work, or why, when I'm looking through a whole bunch of shots, a particular one works. I think that question 'Where am I?' is the ambiguous area of the whole enterprise.

On the other hand, in making an issue out of her physical appearance, Lucas conforms to a widespread tendency among British artists who became successful in the 1990s. There's something about the way these artists put themselves into the picture that particularly expresses our own time. We can easily think of precedents, like Andy Warhol, Gilbert & George and Jeff Koons, who all put slightly false selves into their art. But also, Picasso, Gauguin and Van Gogh, Pollock and Rothko, Frida Kahlo and Louise Bourgeois come to mind. Not all of them do self portraits but it's hard to think of any of them and not

also think of what they look like. Their artistic selves we accept to be absolutely connected to their real selves. And these real selves we accept to be awesome; in fact, so much so that they seem slightly impossible, or too much.

Already, we're coming round to the joke on artistic personality that you get in Gilbert & George – a literal doubling of something that's supposed to be marvellously unique, by definition. And from them you get to the kind of masquerade personality we expect to find in the revelation of self in Gillian Wearing's art, or in Tracey Emin's, Sam Taylor-Wood's and Sarah Lucas's, to name just four of the most celebrated female British artists of the 1990s.

Gilbert & George were formed as artists in the 1960s, when progressive art still had a correlate in an idea of a progressive society. But these last figures grew up and were formed as artists in the 1980s. This was the decade in which British society started to become obsessed by celebrity. It might be said that our celebrity-obsession or celebrity fetishism is a kind of justification for individualism. Or to put it another way, ruthless individualism – vote not for equality but for the right to buy your own council flats – is the ideology, while celebrity-obsession is the expression of the ideology: a thing accepted to be of dubious value becomes the only value everyone acknowledges.

When these artists make themselves into celebrities, the popular audience sees iconic images that stand for ideas the audience has been taught to believe are interesting. But the audience doesn't really believe the ideas. With Emin, the idea is of an incredibly deep autobiographical well of pain. With Wearing, it's that there's an alternative world of Jon Ronson-type outsider kookiness, into which Wearing often inserts herself – maybe she's kooky too? With Taylor-Wood we see the figure of the artist literally on a level with a

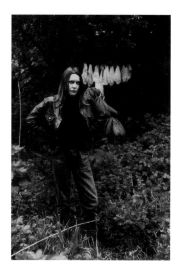

SELF PORTRAIT WITH KNICKERS [47]
from SELF PORTRAITS 1990–1998
1999
Iris print on Somerset Velvet paper
73.7 x 50.1 (29 x 19 3/4)
Tate

opposite: SELF PORTRAIT WITH
SKULL [48]
from SELF PORTRAITS 1990–1998
1999
Iris print on Somerset Velvet paper
73.7 x 76 (29 x 29 7/8)
Tate

lot of celebrities from the entertainment world, and we wonder if we're supposed to be impressed or slightly despairing – here, the idea is the semi-religious aspect of celebrity. With Lucas we see her in Doctor Martens having a mug of tea and a fag. Or we see the same boots on their own, on a plinth, standing for her, with no comment, except for razor blades inserted. And the popular idea is masculinity under threat (rather than an intimate self portrait as such). But what is conveyed to the audience as much as or more than these notions, is success – celebrity is the big popular sign of success.

With all this imagery the audience is being asked to go along with a kind of advertising ethos, in that the artists present a type of imagery that is both hypnotic and empty. It's clear there's a lot of role-playing, something deliberately unreal. And a sense that it is almost certainly not the point of this work to attack – in a virtuous intellectual version of a Girl Guide sort of way – the stereotype versions of identity and the self that come from ads. Even though it's often blithely stated in the PR material and apologia for the art that this is exactly the point. But whatever the point really is, it seems to involve bringing the way imagery operates in ads into the way art operates.

This is the stage at which someone desperate to find something ethical in art with which to combat emptiness tends to throw up their hands: 'These artists are right-wing! And so is this book!' In fact a whole new wave of post-YBA art has now arisen that is designed to answer this complaint, concerned as it is with a clichéd idea of what it might mean to be critical. For example, in 2001 the artist Jeremy Deller got a lot of attention from the papers and the art press, for getting real people to dress up as Yorkshire miners and police to re-enact the 1983 miners' strike, in order to express an involvement with 'politics'.

The point about Lucas's self portraits, though, is not that they fail to rise above empty values or to provide a convincing model for tearing down an inhumane social system. It's that you're being asked to think much more specifically and intelligently than this – you're being asked to look at how iconic imagery works. Why do they work at all? What's the difference between one of them and another? What do the various ways in which they work tell us about our present moment?

It's not that these questions can be easily answered: 'Lucas's self portraits become iconic because they're so mysterious and so anti-personal: so anti-celebrity, really!' In fact, the photos are not easily resolvable, but they're not mind-blowing intellectual connundra either; they're mysterious partly because they really do seem empty. Emptiness is their trick.

Ads showing idealised versions of glossy femininity appear empty because they seem generalised and impersonal and consequently unreal. With Lucas's self portraits the style is unadorned and immediate. While we know she really does look like that, they don't seem to express the 'truth' of what it is to be her, any more than ads express the truth of existence.

I wasn't trying to be sexy with any of them, because I wouldn't do that anyway. But at the same time I didn't particularly have any preconceptions about the result. I was aware of what goes on in advertising but, well – I often do things at speed, so that even though, in a kind of assimilated way, I am aware of lots of stuff, I'm not necessarily consciously thinking of that. And what you get back is often hard-hitting but at the same time it retains a sort of ambiguity. I think those self portraits are still very ambiguous in lots of ways. Although people think the key is that the look is 'masculine', that alone doesn't really catch up with what's particular about them.

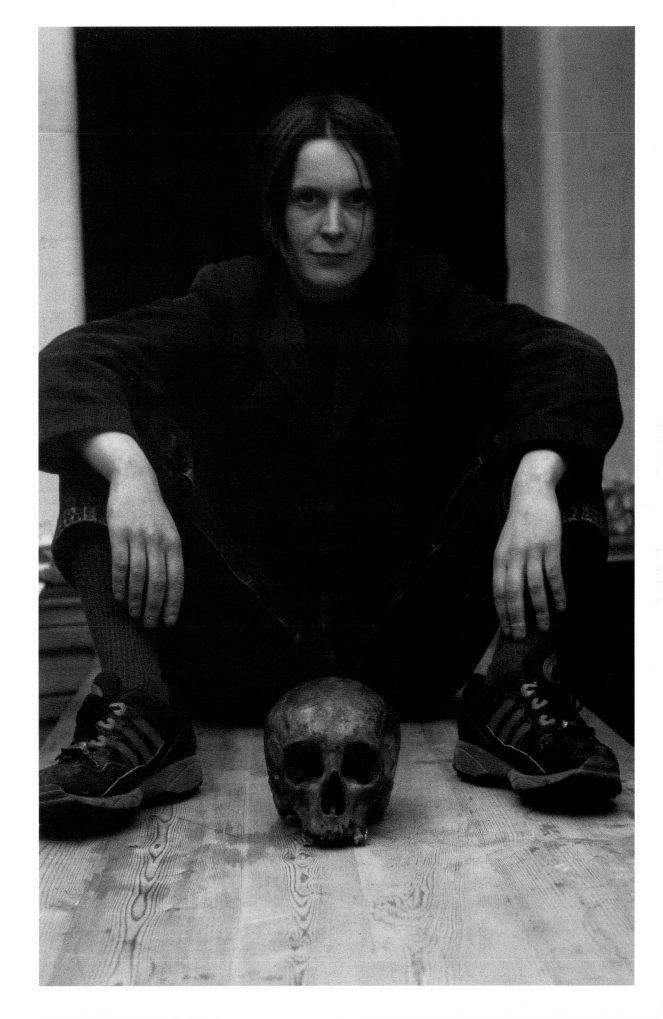

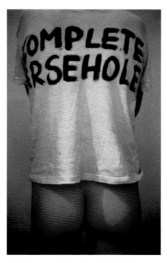

COMPLETE ARSEHOLE 1993 [49]
C-type print
Frame size: 92.5 x 66.5 (36 3/8 x 26 1/8)
Mr and Mrs Edward Lee, London

opposite: GREAT DATES 1990–1 [50]
Photocopy, collage, paint,
photograph on masonite
223.5 x 143.5 x 5.1 (88 x 56 1/2 x 2)
Private Collection

Because a grungy look is perfectly OK in fashion ads, these self portraits could well be ads, except they're not advertising anything. They might be ads for her, or for her art, it could be argued. But what do they really tell us about what she is and what her art is? Isn't it more that they're something in themselves? They're partly gags to do with gender and partly philosophical questions about what art is. They ask, 'If this is art, what are its extreme edges before it becomes something else?'

Lucas's self portraits are always photo-based, but not always presented simply as photos; they're occasionally altered or added to in some way. They have a very limited set of poses and props, and they often refer to other versions of themselves, to other works by Lucas in different media, and to art by other artists.

Eating a Banana (fig.13, p.20), is a close-up shot of her doing exactly that, in black and white. The same image appears in *Great Dates*, of the same year (1990, fig.50). What's good about *Eating a Banana* is its bare-faced challenge: it's going for a kind of obvious sexy glamour but because of the stripped-back, anti-gloss quality, the glamour is only in your head. What's different about *Great Dates* is that the sexual politics is almost literally laid out like information on a notice board. The photo is used in this work as part of a painted collage, the rest of which mostly consists of newspaper pages with girlie pin-ups and news stories. These range from idiotic offences in restaurants to rape and murder. On one side of the rectangle are such headings as 'CRICKET YOBS IN RIOT', 'FULL STEAM AHEAD', 'COPS FOIL CHOPPER JAILBREAK' and 'BANNED FROM ALL INDIANS', as well as a neat row of prostitutes' cards. Above Lucas's head you can pick out a tiny 'YES' and 'NO' and a cartoon noose.

An early photo, *Fighting Fire With Fire* 1996 (fig.45, p.58), showing Lucas smoking and frowning

into space, is re-done as two rows of ten copies, each taking up an entire wall in a gallery, the whole thing toshed-over with transparent washes of acrylic paint (fig.46, p.59). Both the repetition of the image and the use of an interior decorator's choice of colours – vivid yellow, shocking pink, bright orange – puts the work in an Andy Warhol frame – his *Cow Wallpaper* 1966, for example. Another image of Lucas smoking, her face upside-down, smoke coming out of the mouth, but no cigarette visible (*Smoking* 1998), recalls her own sculpture, *You Know What* (fig.30, p.42), with its association of the well-known joke about smoking after intercourse, only transposed to fellatio.

The self-referencing can seem comically self-aggressive, as in Picasso's jokes on his own career. This is the case with multiple shots of the basic mug-of-tea-and-a-fag pose, which in one work are enlarged and laminated onto cut-out steel shapes, and suspended from the ceiling as an outsize Alexander Calder-type mobile (fig.53). It seems to be an executive-toy version of the original, sold from the Bethnal Green Shop, which was only a few inches high and in which humble little cut-out snapshots hung from threads on a wire. In another photo (*Complete Arsehole* 1993, fig.49), her nude behind is seen, with a T-shirt above that has the slogan 'COMPLETE ARSE-HOLE' written on the back. It's like one of her table sculptures, where food becomes a sign for a body; only here one of the signs is also the real thing, and the other is a written-language version.

Another jeans and T-shirt shot, everything focused on the crotch, with a beer-can penis in the centre (*Tomfoolery* 1998, fig.51), appears to be a joke on all her own exaggeratedly unladylike poses. Freudian associations of penis envy, and of something ancient and profound, which can never change – the war between the sexes – might be part of the joke. A work

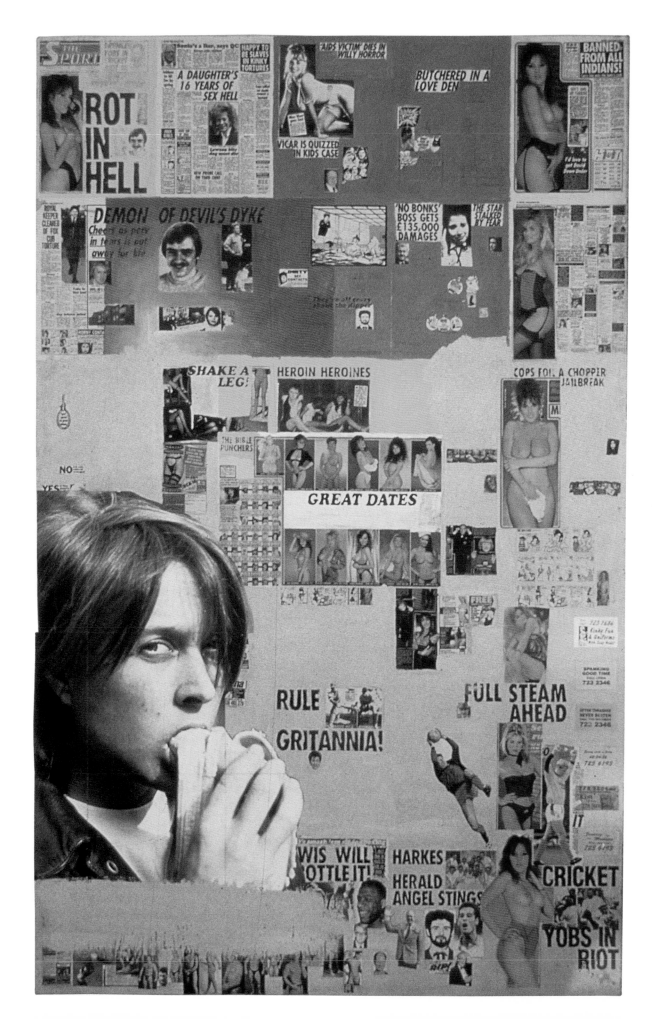

TOMFOOLERY 1999 [51]
R-type print
60 x 80 (23 5/8 x 31 1/2)
Johannes Becker, Cologne

opposite: THE LAW 1997 [52]
C-type print
123 x 99.5 (48 3/4 x 39 1/8)
The artist and Sadie Coles HQ,
London

ME SUSPENDED 1 1993 [53]
C-type prints, card, metal, wire
Dimensions variable
Jay Jopling, London

(*The Law* 1997, fig.52) showing Lucas with legs astride a concrete cast of a TV set into which the words 'THE LAW' are carved, and above the set an opened-out copy of the *Sun*, which she's reading, presents a variation on the same theme.

Clothes are significant in every shot. Boots and other footwear are always male-imitating. A variation on her pair of boots presented as a sculpture is a sole of a boot presented to the viewer in a self portrait using extreme foreshortening – the sole, flat against the picture plane, is about one-third the size of the rest of Lucas's body. In later photos she looks like a successful creative type of the late 1990s, in advertising or publishing or art. In earlier ones she's more like a stereotype from a TV play about disaffected youth. No consistent personality builds up exactly. The sequence of images represents a play on a notion of self and of what it is to be feminine – and a playing-up of a certain type of androgynous appeal – not an attempt to create a convincing fiction.

The celebrity theme of these self portraits can't be ignored (on the grounds that it might be a bit tasteless) in favour of a more intellectually respectable notion of identity, because they're seen in a social context where celebrity *is* identity. (It's enough of an identity to be a celebrity.) The challenge the self portraits offer – to be thought of as an achievement of some kind while appearing to be very little, or almost nothing – makes sense if you think about them in terms of celebrity: they accept that celebrity is nothing. Even less is attempted than is sometimes supposed. Rather than setting up a new icon of defiant modern attitude, they really are about Lucas being herself, and this self is nothing special. She just has a few quirks.

Everyone makes his or her appearance into a bit of a language. You know what you mean and you know what you're avoiding. I've always been quite tomboyish. And I've always been quite squeamish about what's intentional and what's not intentional, with the way clothes are worn, and the potential embarrassment in what you're saying with them – especially sexy clothes. But even things like shirt-collars and ties – I used to have an aversion to collars and I still don't wear them much. So while it could be anyone in the photos, I would still say it's about my own identity, in a way. I mean, I don't dress in a special way and then turn up for a photo – but then again, I do, because dressing is always special. You could make a sculpture and there's something about the style of it that's saying something that you don't personally mean – so you have to be careful not to do that. And of course sometimes you don't know what you mean, because sculpture is all about what's actually present. You can't avoid anything or get away with anything – you have to deal with it and leave something there that you can live with, and about which you can actually think: 'Yes, I identify with this. I don't mind being identified with this.' And all this is exactly the same kind of statement you make in what you do and don't do, with your clothes.

It would be wrong to say the photos are dead ordinary exactly, but there are plenty of things that certainly you wouldn't particularly aspire to – the hang of the jeans at that moment, say. Those imperfections are part of it, perhaps the most important part. The stance isn't about being perfect. It's almost an ideal not to be perfect. It can only be adequate, really. And there's a kind of dream in that, where you see the ideal but you have to live with the imperfections.

The received idea that these works have 'attitude' is merely a reference to Lucas posing like a man, sitting with her legs open, and putting on a look of abstracted anxiety, or frowning blankness, instead of looking fluffy or glossy or pleasing. The implication of the term as it's used in the media is that it forces the

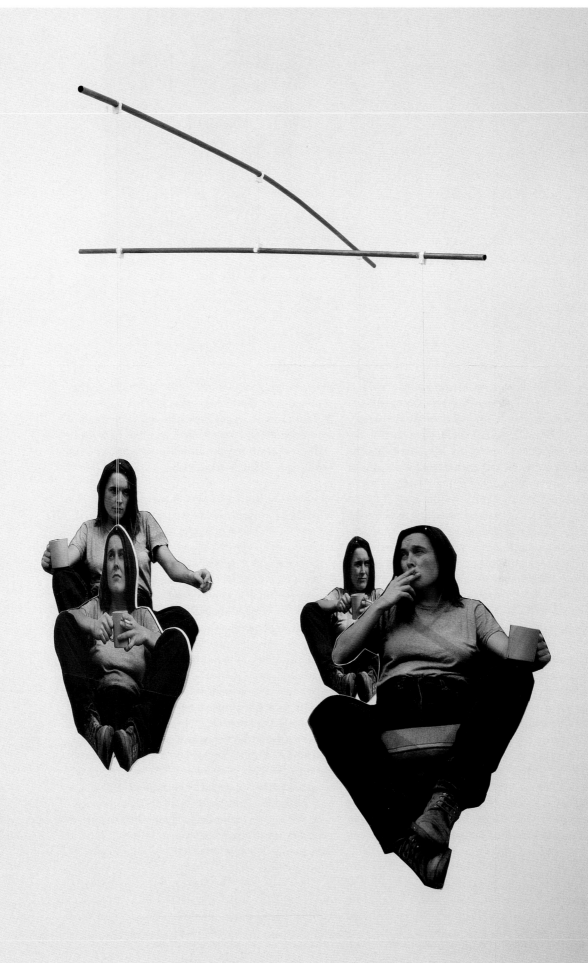

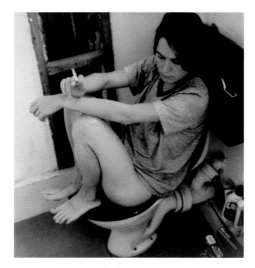

HUMAN TOILET REVISITED [54]
from SELF PORTRAITS 1990–1998
1999
Iris print on Somerset Velvet paper
57.5 x 54.8 (22 5/8 x 21 5/8)
Tate

HUMAN TOILET II [55]
from SELF PORTRAITS 1990–1998
1999
Iris print on Somerset Velvet paper
73.7 x 48.9 (29 x 19 1/4)
Tate

viewer to reconsider long-held assumptions (and this is good). 'Attitude' is almost correct in the context of her work, since she makes a play on gender stereotypes. On the other hand, she doesn't do that any more than modern ads often do themselves – it's just that with her the look is natural, and it's a case of thoughtfully isolating and framing something that is always immediately to hand.

Lucas's blank expression is a key point, since she can make blankness seem like richness. Sometimes blankness clinches the picture, for example, in the fish photo (*Got a Salmon On #3*, fig.38, p.50). The fish is a derogatory comment on femininity as well as a classic phallic symbol. But a woman is making the joke, plus the fish is a real whopper, and look – she isn't even horrified! At other times the blank expression appears to be there precisely in order for the face not to be the focus, as in the one where there's a row of underpants on a washing-line in the background (*Self Portrait with Knickers*, fig.47, p.60). The blank expression in *Eating a Banana* (fig.13, p.20) is different from the blank expression in *Self Portrait with Skull* (fig.48, p.61). The first is possibly slightly furtive, while the second has a kind of inner secret knowingness that we conventionally attribute to the smile on the face of the Mona Lisa.

Emotional blankness as sphinx-like is something we associate with Warhol – his self portraits, too, have a kind of intimation of significance which, when analysed, often turns out to be merely the way he has of making you think of his other works and his store of Warholian meanings. As well as a joke on ideals of femininity in ads – and on masculine aggression against the feminine in rude jokes – the fish in *Got a Salmon on #3* references another fish joke in one of Lucas's sculptures, the kipper in her sculpture *Bitch* 1995. This sculpture in turn is a variation on *Two Fried Eggs and a Kebab*, but with a kipper tacked to the edge of the table, replacing a kebab sitting on the tabletop.

In one photo of herself naked on a toilet (*Human Toilet II*, fig.55), Lucas holds the disconnected cistern in her lap; she looks downwards and away. Her blankness is pretty total, mainly because you can't see her face at all; instead you get a sense of the whole cubicle: the pipes, the grungy walls. She seems to be actually imitating a toilet (as in children's drama groups, where the teacher says: 'Be a teapot!'). The symbolism seems to be about abject sexuality: 'I am the lowest sexual rubbish'; or just abjection: 'I am rubbish.' In either case the toilet metaphor is clear. But in the case of *Human Toilet Revisited* (fig.54), where she's squatting semi-naked on the toilet, knees right up, in an awkward position, smoking, there are either several metaphors, or no metaphors, or a lot of ambiguous possibilities, or only ambiguity. Her blankness might be inner-reflection, seriousness, intensity, longing or sadness – in other words, not blankness.

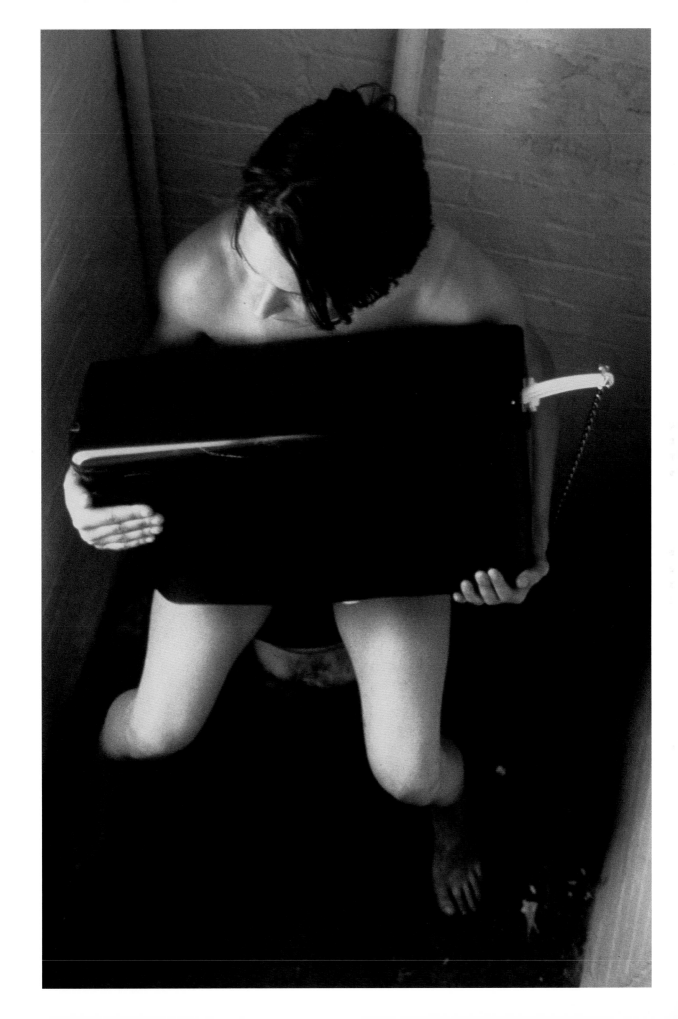

opposite: GOT A SALMON ON IN
THE STREET #2 2001 [56]
Black and white photograph
157.5 x 105.4 (62 x 41½)
Thomas Dane, London

Most commentary on *Human Toilet Revisited* ignores the odd way Lucas is sitting. It assumes the point is some kind of instructive authentic normality, a homily about what it is to be an independent woman having a fag, not caring what anyone thinks, especially men. Again, the pose is an imitation of the toilet but in a slightly different way. Perhaps it would rationalise it to imagine that she's not alone but sitting talking to someone in the bath. But we know there's no bath because we've seen the same cubicle in other photos. And in any case it's just as hard to believe that's the real point of the photo as it is to believe that *Human Toilet II* – in which a feeling of staged unreality is much more emphasised – really expresses what it's like to be knocked out by patriarchy. Neither is 'really' anything but a series of feints and teases based around a mildly striking natural appearance, itself the product of a lifetime of careful little self-conscious adjustments.

Well, whose identity is it? What identity am I talking about? This is the biggest idea buried in the whole thing. That's the real idea of it. The idea of wanting to be your own self, even if anyone really had a clue what that is, and even supposing they actually wanted to know.

Lucas recycled twelve of her self portraits in 1999 to make a set of prints. They were resized and reprinted on classy, heavyweight paper. Processed in this way, they virtually became ads. They became promo shots – museums could buy a set to advertise their Sarah Lucases. Since the set had all her well-known themes running through it – sex, death, smoking, gender-uncertainty, food, grungy roughness, modernity, everyday bits and pieces lying around – it promoted her art generally, as well as the original individual photos.

Most were first shown as single works in the company of other pieces, usually sculptures. As a set, the collective effect is a kind of ripple of 1990s-style grunge-glamour, distorted in different ways but still comprising a single entity.

I was thinking about identity early on partly because of my financial circumstances. I hadn't had a job for a while. That's OK for a bit but then there's a certain point where you realise everything you've got is completely run down and that, really, you can go too far with your own dourness – you can get too far run down, without realising it's even happening. I'd almost begun to take on the appearance of a kind of butch lesbian, and I never wanted that – I might have wanted to be on that edge but not to go right in for it. But also, I definitely didn't want the other extreme. I mean, I see that other extreme all the time. I see the absolutely flagrant kind of flirtatiousness of these women at the Groucho Club, say, who tag along, and the ridiculous terms it gets put into. And I just think, 'Christ! How can they do that?' It gets pointed out that I don't do that flirta-tious thing, but what always surprises me is that anyone should find that surprising.

I never liked being in photographs and I avoided it if at all possible. I thought I looked masculine in a way I didn't always find palatable. But in that picture with the banana, the first of those photos, you can see that those considerations of whether you looked particularly good that day, or whether or not you look a bit more masculine than you like to look, were in the service of the picture. They weren't in the service of vanity. I did it with Gary Hume in our yard, and when they were printed one of them just stood out, because it was funny. (It was always Gary's little son Joe who'd spot the strong one, and we'd agree with him.)

At about the same time, I had this double-page spread from the Sport, *which was about the hot weather that had just broken out. It said 'SHINE ON' in great big letters, and it had this woman in a T-shirt and pants, with an ice cream. It was such a great picture. I loved it, but it was obvious to me, doing the banana thing, that even though there's the same issue of titillation, my stance is different.*

I had one clear idea for Fighting Fire with Fire, *which was to get a long ash. It's difficult to get it to look natural and not have tears streaming from your eyes. So rather than trying to look 'defiant', that was the only one where I looked at all natural. But even then I wasn't necessarily going to make much of it; it was just a project for the* Idler. *It got printed in the magazine on very grainy paper, and I took that version and blew it up. And that's why the version you now see is so grainy. This whole 'defiant' idea is really to do with texture. I probably wouldn't have wound up doing it like that, and yet that's the one that's most well known. It's the one picture where you can see what an influence texture really has on people's perception of what the photo is conveying.*

The one where the line of knickers is behind me – the fact is, I forgot they were there. They weren't part of the idea necessarily, but now they seem to make the picture.

The effect of the photo with the fish is partly to do with me, partly the graininess of the photo, partly the dourness – all those things. They were accidental, because I just had the idea and I did it as quickly as possible.

You never know if it's enough. You can't make it enough by just having another idea, because the real action is quite subtle. In some ways it might have been better if I'd just stood with a mug of tea and a fag and never deviated from that, because the deviations are not the most important thing – being laconic is quite important.

When I'd done a couple, I thought, well, OK, this is something I could do. But even then I was wary of over-using it. And now it gets harder to go on with it. It's not just a question of repeating myself. There's also the question of getting older and how that changes the meaning – it changes the look of what you're doing.

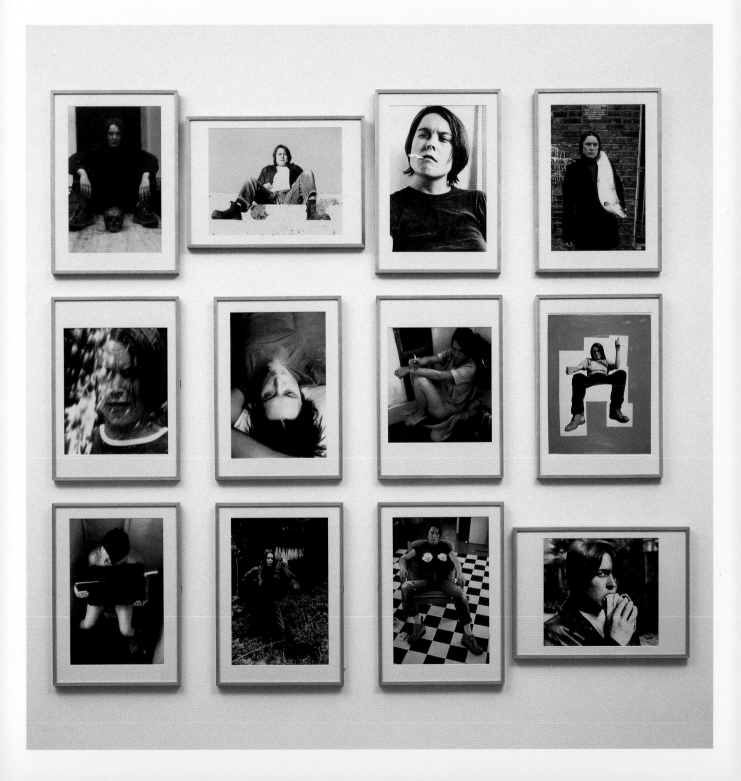

THE OLD COUPLE 1992 [58]
Two chairs, wax, false teeth
Two parts, each 87 x 40 x 40
(34 $\frac{1}{4}$ x 15 $\frac{3}{4}$ x 15 $\frac{3}{4}$)
Norman and Nora Stone,
San Francisco

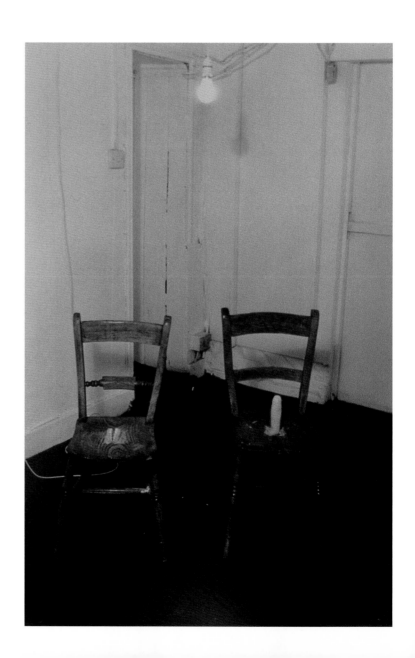

NEW RELIGION (BLUE) 1999 [59]
Neon coffin
39 x 55 x 181 (15 ¼ x 21 ¾ x 71 ¼)
Installation view, 'Beautiness',
Berlin 1999
Paul Maenz, Cologne
Courtesy Contemporary Fine
Arts, Berlin

OH NO, NOT SEX AND DEATH AGAIN

When I read about my work I often feel, 'Oh no, not sex and death again!' The thing that's objectionable is to feel the sex-and-death emphasis is reductive. Obviously making sculptures is a very reduced activity in comparison to living a life.

Sex and death often pair up in Lucas's work, either quite obviously or in more subtle ways. Sometimes there are objects that directly stand for death, like a coffin, in conjunction with obvious sex symbols. Or there's a juxtaposition of works in the same show – a sex work and a death work. And sometimes it's futility and hopelessness more than death exactly, although in these cases one can usually track down a death meaning behind whatever else is on offer.

In 2001 Lucas collaborated with the dancer Michael Clark to put on a ballet at Sadlers Wells. The objects she provided as props or sets included a mechanical wanking arm, a circular metal cage and some standard lengths of neon-strip lighting (fig.60). The arm was huge, dominating the whole stage. At one point a film screen showed an anonymous male masturbating against a wall, with a video time-code at the bottom of the picture, measuring out the minutes and seconds. There was no climax; the film – which had the static grainy quality of a bit of enlarged CCTV footage – just came on and after a while, stopped.

This dance was the second part of a two-part show. In the first, not involving Lucas, Clark's troupe did amusing sexy things to each other, wearing costumes that completely revealed the male and female performers' naked arses. In her part they wore absurdly large old-fashioned Y-fronts and the sex was all masturbation, the only variation being when it was mutual rather than solitary. They came on holding fluorescent tubes, like symbolic fragile phalluses, then exited. A dancer crossed the stage on points, within the mobile circular cage. The rest of the

performers then emerged again, wearing wanking arm-extensions. While the wanking video ran they performed a wanking dance, which ended with them pretending to wank each other off. The giant arm was then wheeled on. The sexy dance the performers executed around it included a movement where the dancers' whole bodies appeared to be phalluses, which were held within the up-and-down mechanically gesturing fist of the wanking arm.

A sense of sex in this ballet as something slightly despairing, which never ends but either isn't connected to anything or is only something to put in front of a terrible void, was reminiscent of Lucas's sculptures of the early 1990s. With these works, furniture and other mundane objects become sexy couples in darkly comic, slightly deathly situations. The mattress in *Au Naturel* 1994 (fig.63) is stained and old. The 'female' toilet in *One Armed Bandits* 1995 (fig.61) has a cigarette butt floating in the bowl. A wanking arm attached to a chair in the same work looks like a broken limb in plaster, suggesting a Duchampian theme of perpetual unsatisfaction, but also a pathetic oldster with fragile bones. The *Steptoe* theme is continued in the way the chair is dressed in underclothes. Somehow the underwear's very straightness (white, nothing fancy, no designer label) suggests old people, and so does the broadness and ungainliness, because the items have to be stretched over wide awkward angular shapes, not svelte youthful ones.

Because of the minimalism – there really isn't very much there and that in itself might be a metaphor for existence – and the way minimalism is coupled with suggestions of ageing and death, these works have a Beckett-like atmosphere. A stripped-down aesthetic suggests directness, a lack of illusions. But illusions might include a sense of humanity and hopefulness,

The Michael Clark Dance Company
BEFORE AND AFTER THE FALL [60]
Still from performance in Berlin,
2001

ONE ARMED BANDITS (MAE WEST)
1995 [61]
Chair, toilet, candle, underwear,
plaster and steel
Dimensions variable
Museum Boymans van Beuningen,
Rotterdam

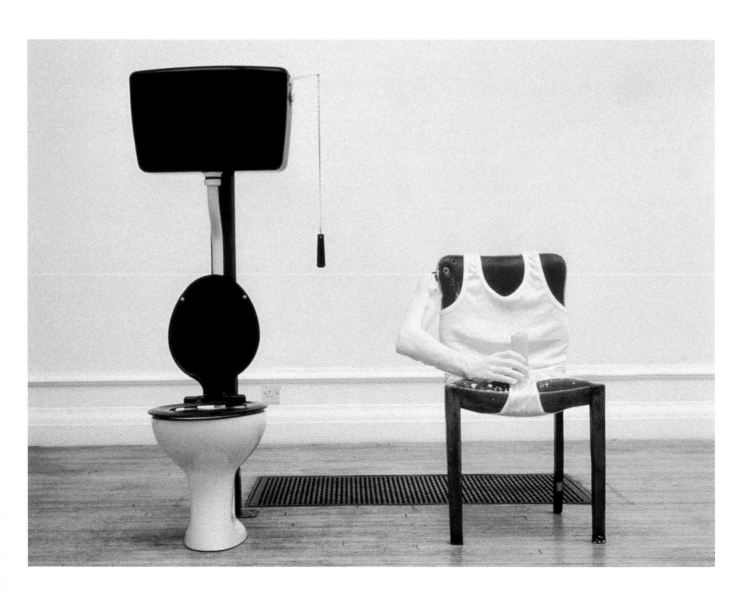

Robert Gober
UNTITLED 1984–8 [62]
Plaster, beeswax, human hair,
cotton, leather, aluminium pull tabs,
enamel paint
85.1 x 101.6 x 62.9 (33 1/2 x 40 x 24 3/4)
Private Collection

below: AU NATUREL 1994 [63]
Mattress, water bucket, melons,
oranges and cucumber
84 x 167.6 x 144.8 (33 x 66 x 57)
The Saatchi Gallery, London

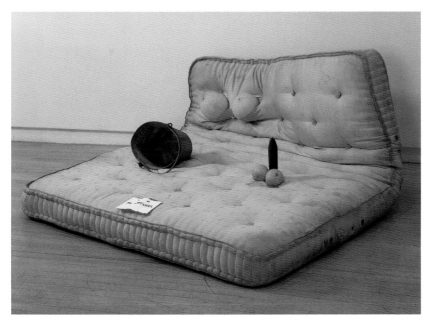

which when you're old you might wish you still had. Of course Beckett's old people lost theirs long ago. And without comforting illusions, the mood is black, and the jokes – Lucas's black *joie de vivre* and her formal wit, and Beckett's brilliant endless quipping and griping flow – tend to revolve around futility. For example, *The Old Couple* 1992 (fig.58) is just two chairs lined up, an erect penis on one (cast in plaster from a dildo) and a set of false teeth on the other. The false teeth make a black-comedy vagina, but both objects might be black comedic comments on ageing, one by ironic exaggeration ('My, you're virile!'), and the other by grotesque displacement.

Today sex and death are merely conventional subject matter for artists, like nature used to be. The grim, the low, the bleak, the perverted, the disgusting, the horrible – these are the common features of the new landscape. It's not a poetic take on the extremes of existence, but more that sex and death are frequently concretised in a modern, often literal and obvious way. However, different types of energies animate this material. For example, the rhetoric surrounding the work of the celebrated US artist, Robert Gober (who does bodies and body parts), is about expressing a sort of social unease – basically unease about the way society treats homosexuals. But although Lucas is a feminist you couldn't say Women's Lib replaces Gay Lib in her case. At its heart Gober's subject matter, his mannequin-like legs sticking out of walls, his sinks that are also hairy human torsos, or which have creepy appendices (fig.62), is violence. When you see one of those whimsically repulsive sinks you really do want to put it out of your mind, because it's revolting. Lucas puts forward a lot of questions but she doesn't set out to make an audience feel disturbed in that way.

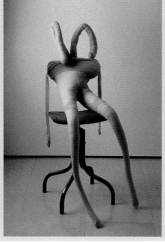

Farrow Design invitation card for
'Sarah Lucas – Beyond the Pleasure
Principle' at the Freud Museum,
London, March–April 2000 [64]

In 2000 Lucas put on an installation at the Freud Museum in north London, called 'Beyond the Pleasure Principle'. All the works had sex. Partly because of the literal context, partly the title, and partly because one of the works featured a coffin, they all seemed part of a single Freudian idea structure: that sex is life, death is the opposite, and there is something compelling about the pull between the two.

One of the works (*Prière de toucher* 2001, fig.66) was a photo of Lucas's own torso in a grey T-shirt, with a nipple showing through a hole in the cotton as if purely by accident. It was an enormous image, reaching from the skirting board to the ceiling, and placed by Lucas so that it loomed over the famous couch like a dream. It relates to all the headless female nudes she's done – her concerns became fixed early on, then hardly changed – but it has its own character. The room already had photos in it: stern portraits of Freud, faded views of the Egyptian desert. But this large unframed C-type print, with its 1980s feel (increasingly familiar in the 1990s) of Joe's Basement developing and printing shops intersecting with international corporate art galleries, was incongruous. And so was the T-shirt in a basically Victorian environment. But since it was in Freud's house, the exposed nipple was right, because he's all about exposing disguised sexual meaning. On the other hand Lucas's meaning was all about non-disguise, so this work was more about contemporaneity than about Freud.

The publicity card for the show (fig.64) matched two famous photos: Lucas's own *Fighting Fire With Fire* from 1991 and Max Halberstadt's *c.*1920s photo of Freud smoking a cigar. Next to this classic image of intellectual authority Lucas's image seems like a stereotype of rebel creativity – a Rimbaud for an audience that largely hasn't heard of Rimbaud. Of course, she inhabits a world of different expectations about creativity and meaning from either Freud or Rimbaud, and a modern popular audience is fascinated by 'image' in a way that can't be transposed onto a previous age. Freud said the conflict between the death drive and the sex drive explained 'the great variety of life's phenomena'. But art doesn't necessarily have to explain anything.

Freud's frown denotes intensity and seriousness – 'cigars are this great man's only worldly pleasure' – whereas Lucas's frown is merely intense concentration on the act of getting a long ash while trying not to get smoke in her eyes. But if there is definitely a gap, both are successful sex artists – Freud from a Victorian world of repression and disguise, where meaning seethes in hidden depths, waiting to be dredged up, and Lucas from a world that defines itself in opposition to that world. (Where everything is direct and on the surface and so people often fear that nothing really means anything.)

All the works were distributed in different parts of the house. *The Pleasure Principle* was in the dining room, and actually used Freud's dining table, as well as two of his chairs (fig.65). Each chair was dressed, one in pants and vest, the other in pants and bra. One chair was on the floor and one on the table, with an eight-foot neon tube connecting them, one end of the tube in the 'lap' of the male chair on the floor, the other up the underside of the female chair on the table. *Beyond the Pleasure Principle* was upstairs. This is the sculpture of a male and a female body made up of fluorescent tubes, ordinary light bulbs, a futon, a bucket, a clothes rack and a cardboard coffin that I described in the first chapter of this book. As well as *Prière de toucher*, there were two further works in Freud's study. These were papier-mâché splayed legs, each made from a pair of tights, each called *Hysterical Attack* and each covered in cut-out images from magazines, one all mouths (fig.67), one all eyes.

THE PLEASURE PRINCIPLE 2000 [65]
Chairs, neon tube, lightbulbs, underwear, table, lights
116 x 181 x 251 (45 5/8 x 71 1/4 x 98 1/2)
Installation view at the Freud
Museum London, March – April 2000

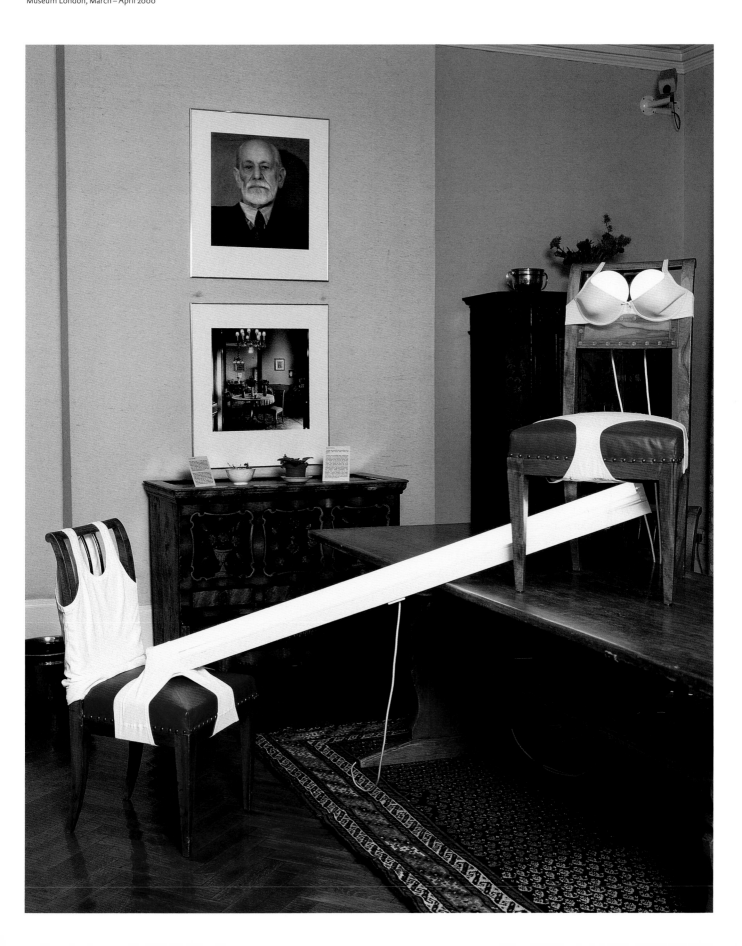

opposite: PRIÈRE DE TOUCHER
2000 [66]
C-type print
297 x 178 (117 x 70 1/8)
Installation view at the Freud
Museum, London, March – April 2000
Collection Adam Sender, New York

In Lucas's work, sex and death are always specific, even if it's specific only in order to be jokey. They're never indicators of general profundity. Part of the specificity of the works included in 'Beyond the Pleasure Principle' was that Freudian symbolism wasn't something to be uncovered by intellectual detective work but was directly visible. The public roughly knows that Freud said dreams are 'the royal road to the unconscious'. But Lucas doesn't normally explore the unconscious, and nor did she in this show, since its subject matter was really clichés of the unconscious: disembodied eyes, sex as a kind of unstoppable bit of mindless machinery, life as pure sex, sexuality as something blind and violent, and so on. When her work has profundity it's in terms of what it actually is, rather than its references. Its seriousness is in its playfulness.

The implied seesaw movement of *The Pleasure Principle* was a playful expression of the work's 'grounding' idea – monotonous distanced attachment and the notion that interdependence is a necessity but also a curse; and that sexual relations, even human relationships generally, are merely itching and scratching. The old brown middle-European furniture was broken up visually by white shapes: the clean new pants and bras, and so on. The brown was also broken up by the trashy, slightly too-bright fluorescent light, and made spatial by the sculptural arrangement: a wide flat plane and a complicated arrangement on the side of it. This is all part of the work's original creative spontaneous animation.

The mood and associations of *Beyond the Pleasure Principle* (fig.7, p.13) were different. The two works are related, but not in the sense implied by their titles, since neither is really an advance on the other. And in any case neither of the titles is particularly sincere. Rather than being respectable and classy, the objects in *Beyond the Pleasure Principle* are anonymous and classless, but not timeless – time, and the meanings that objects possess when they belong to different times from our own, is a constant throughout her work. The futon is a repetition of the stained old mattress in *Au Naturel* (fig.63). The seediness of the *Au Naturel* mattress is Beckett-like or Joe Orton-like, suggesting the 1950s and 1960s. But a futon is the aspiring yuppie furniture of the 1980s, like black sound systems and little white fitted wall lamps, which all seem quite trashy now.

The rusty old bucket in *Beyond the Pleasure Principle* is trashy in a different way since the meaning of a bucket when it's connected to femininity must be something in which to dump all sorts of waste. The same kind of bucket was used in *Au Naturel*. The fact that it's actually a fire bucket rather than a slop bucket, or a cleaner's bucket, only makes the metaphor more sordid – 'on heat' as well as 'clapped out'. Of course 'kicking the bucket' is in there too, since another of the objects used in *Beyond the Pleasure Principle* is a coffin. It isn't a heavy polished wooden one, which would have classic Surrealist connotations that might upset the careful play-off between significance and playful weightlessness, but a lightweight, modern, biodegradable one of the kind you can get from the *Yellow Pages* or off the internet.

In both sculptures the lighting is harsh but in each it has a different role to play. In *Beyond the Pleasure Principle* the fluorescent tube tears a hole in the futon, plus its brightness is quite hard to look at. Harshness is a principle as well as an effect. In *The Pleasure Principle* a diagonal line of light connects a male with a female, and is itself a male symbol. *Beyond the Pleasure Principle* uses the same symbol but in addition the red bucket has a red light within, and is attached to white-light breasts, the fluorescent phallic tube has globe-

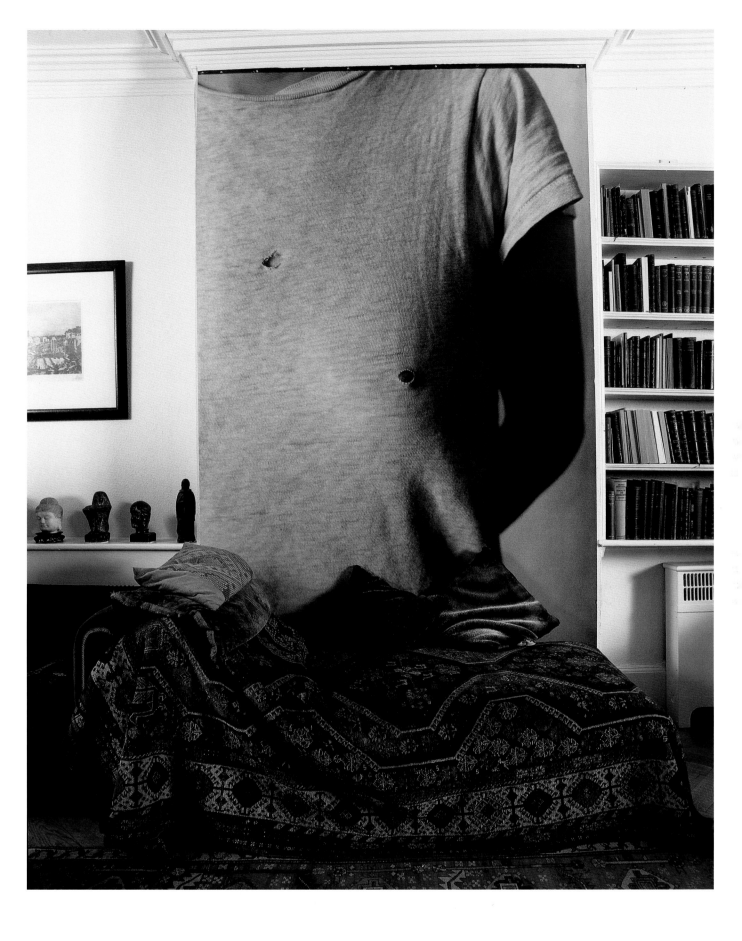

opposite: HYSTERICAL ATTACK
(MOUTHS) 1999 [67]
Chair, papier maché
75 x 82 x 78 (29 ½ x 32 ¼ x 30 ¼)
Installation view at the Freud
Museum, London, March–April 2000
The artist and Sadie Coles HQ,
London

shaped light bulb testicles, and the coffin interior is illuminated by another fluorescent light. Because all these objects emit light or are made of light their conceptual relatedness is emphasised. Certain phrases that contain suggestions of the interconnectedness of love and death come to mind: 'light of my life' and 'lie down and die' – which wouldn't work for *The Pleasure Principle*.

The papier-machéd tights (*Hysterical Attack*) in the study were feminine in a ridiculously abject way, like their parent forms, Lucas's *Bunny* sculptures of 1997 (fig.10, p.16 and fig.68, pp.90–1). But at the Freud Museum the bendy limbs grew out of ordinary hard cheap Holloway Road secondhand-shop chairs, rather than being clamped to them with a metal vice. There was no head, as with the earlier works, but also no torso, merely splayed legs. Around them everything was sober, for the rest of the room is what's left of Freud's daily environment as it was sixty years ago, which even after its museumification is still impressively Freudian. It's all heavy curtains, patterned carpets and rugs, shelves of books by great figures,

cases of antiquities – the Greek, Roman and Egyptian funerary figures Freud collected – and his heavy desk, with his pen stand, blotting paper and spectacles.

The Freudian meanings of the eyes and mouths that completely covered each *Hysterical Attack* might be 'scopophilia' in the case of the eyes – his term for sexual satisfaction derived from looking in a complicated way, which is somehow weirder than mere voyeurism. And in the case of the mouths there is an amazing range of oral fixations in Freudian thought, as everyone knows. But since literal photographic mouths and eyes were right there in front of you, no one had to actually do anything Freudian in order to uncover them. Being entertained by a play of possible meanings isn't the same thing as saying that these were actually calculated into the works.

Apart from the Bunnies, *which took a long time to make, the show was knocked up very quickly, so it was probably more supernatural than calculated. I don't think there was much actual Freud content apart from the literal use of his furniture.*

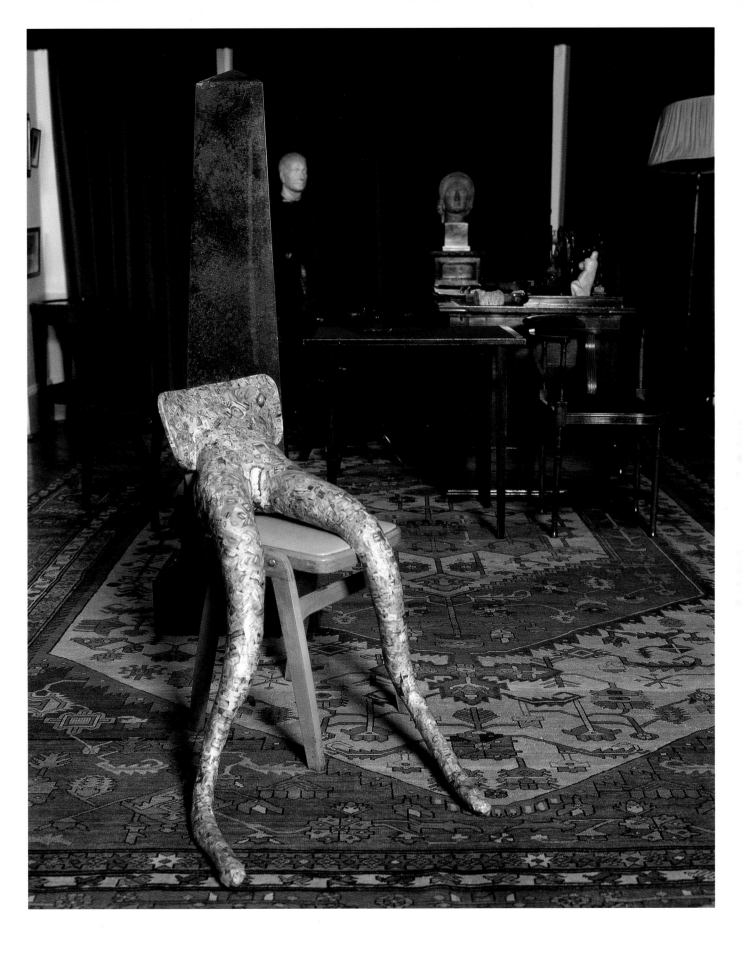

This installation multiplies a single object – a sculpture called *Bunny*. It's a figure on a chair and at the same time the figure and the chair are fused: the shoulders of the chair are the shoulders of the body; in silhouette they might be the breasts. A pair of tights is rolled onto legs that are themselves made out of tights stuffed with kapok and wires. The centre of the object, to which the eye is naturally drawn because all the sculptural movement revolves around that point, is the gusset of the tights.

With each repetition the chair is different and the tights are differently coloured, conforming to snooker-ball colours. A snooker table is a traditional macho object. In this context it takes on obvious sexual symbolism: sticks, balls, pocketing and shooting. As an object it provides a strong dark colour as a foil for mostly light, bright colours and beige, and a single solid large shape that counters several odd irregular wriggly ones.

It's not a significant difference to repeat the thing, really. From a purist point of view you could question it. I'm glad I have a kind of purist idea about art – which I got from art school – because I still use it to a certain extent to decide what's good. It's a part of my make-up. It's how I judge something – some things are better than other things. But I also think, once you've got a platform as an artist you can kind of do what you like. There's still a risk of doing something really bad. That never goes away. But at the same time you've got more licence and perhaps you ought to give it some rein. You shouldn't necessarily be sitting about in a concentrated way, waiting for the next masterpiece.

I'd made an edition using a mould a few years before, Get Hold of This *– the arms sculpture – which I made in plastic. At the time I thought, 'Well, if I'm going to make an edition, why? What's the justification?' So in an arbitrary way I decided to use the snooker-ball colours. And from that I just used the snooker-ball colour thing again with* Bunny Gets Snookered, *only this time I used the table as well. It was just another idea.*

The first time it was shown there was just the one. It was in 'The Law', an exhibition I put on in a warehouse. That place turned out to be so shabby and filthy that when I decided to do some more a few weeks later at Sadie Coles, I thought, 'Right, let's be really graphic and clean'.

When there's a lot of *Bunnies*, and with the addition of the table, the effect is both to lighten the content and to make it more theatrical. It's like a quintessentially male place, but with the males absent and a host of sexist fantasies – perhaps the

fantasies have died and then come back to semi-life as zombies – left behind. It appears to be a satire on pleasing femininity: the *Bunnies* are all sexy compliant softness like *Playboy* bunnies, but look as if all their internal organs have been removed. Instead of a head there are two floppy protrusions, like rabbit ears; two stringy ones round the back of the chair, like arms, and legs that taper to a point; no feet, just tips. You have the feeling the body would slide off the chair if it weren't clamped to the back of it with a metal vice. Their interest comes from the way materials have been used, their rightness as objects, while whatever can be read into them has a take-it-or-leave-it quality.

The vice was just a practical thing, something handy. I couldn't better it, so I left it. It makes sense to imagine it's clamping the figure to the chair – but it isn't really.

The origin of the Bunnies *is a long story. When I had the shop in 1993, I made an octopus out of tights stuffed with newspaper* [Octopus 1993]. *And I really liked it. I thought, 'Tights are so sexy, in a way. So I'll do something else with them'. I started making a hare and tortoise out of tights but it never worked out because I couldn't manage the tortoise. The idea called for it to be put together with such simplicity and for the objects to work so well, but I couldn't pull it off. I used a washing-up bowl for the tortoise's back, but I couldn't find the right thing, and it wasn't easy – and it's the wrong sort of approach to get into some really laboured way of making a thing. But anyway I got some wires inside the tights and I had newspapers in them, too. And then when I abandoned the hare and tortoise idea, there was something about these grey legs, those grey tights. I put them on some shelves. I thought there was something human about them. So I held on to them for a while before chucking them out. And years later, I don't know why, I started on them again. I'd made a cage* [Round About My Size 1997] *for 'The Law' and I wanted something to go with it, something quite sexy. So I got the tights idea out again. But this time I stuck the chair in. I didn't know where I was going with it; I just thought, well, I'll start again with that. And I just happened to have a chair around that had a certain kind of back. And once I'd got the legs actually stuffed, I wanted to see how they looked, so I just clipped them on the back of this chair and that was it. I added a couple of things, but really that was it. It was brilliant. It doesn't happen very often that you really get that 'Eureka!' feeling, and you want to grab a beer or suddenly laugh, and smoke fags really fast, and phone people up and say, 'You've got to get over here!' Which is one of the things you dream about. And*

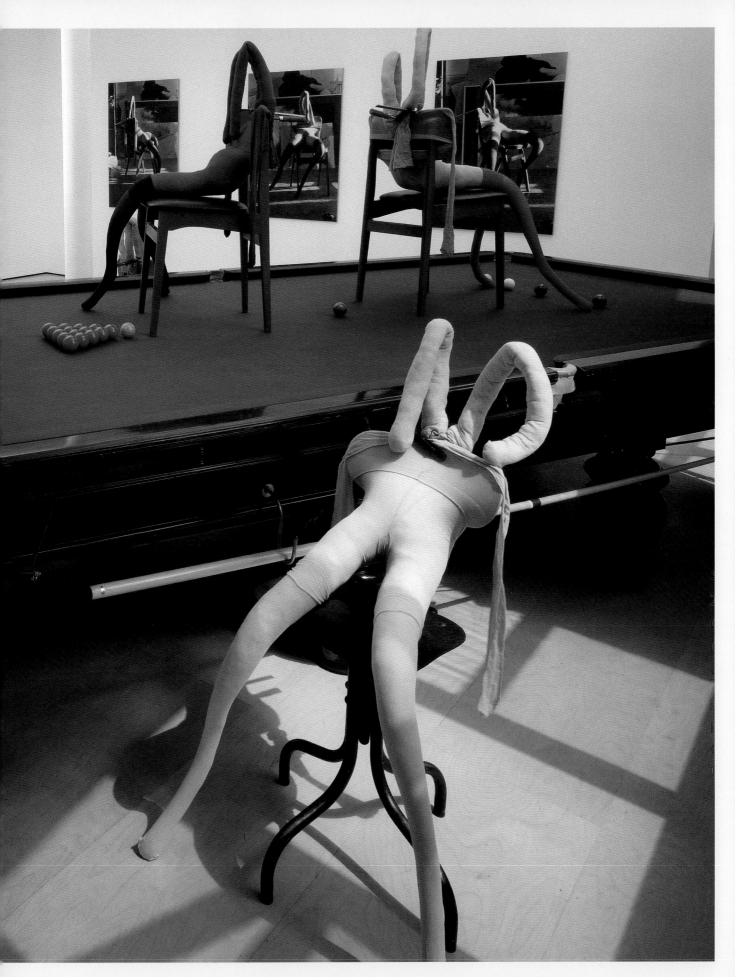

funnily enough, people say, 'Why's your stuff always about sex?' or something silly like that, but I often didn't start with that. It doesn't actually turn into anything until it gets there.

Allen Jones is a reference because of his Pop art furniture-women – fibreglass figures in rubber gear with open mouths, like sex dolls, which double as tables or chairs (fig.69). Beyond them are Hans Bellmer's Surrealist dolls, from the 1930s, which always seemed crass but which have recently been rehabilitated as serious, because of current art's obsession with the psychology of sex. Bellmer took classy well-lit photos of his dolls, and in this installation Lucas, too, includes a set of large black and white photos of the *Bunnies* (*Black and White Bunnies* 1997).

 Looming over Jones and Bellmer are all Picasso's sexy women. In its headless splayed floppiness *Bunny* parodies the kind of generic female body that Picasso paints, in particular his nudes of the 1920s and 1930s (fig.70), but also the monster ones from his late period. The first tend to have tiny heads and big bodies, like cartoon representations of male lust. The second are lusty in a rather crazy way: faces all doolally, limbs splayed, pissing in dynamic zigzag gushes, flashing cubistically disjointed and exploding breasts, behinds and genitalia, and hairy armpits.

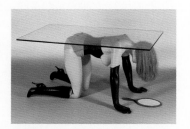

Allen Jones
TABLE SCULPTURE 1969 [69]
Mixed media
61 x 85 x 145 (24 x 33 ½ x 57 ⅛)
Private Collection

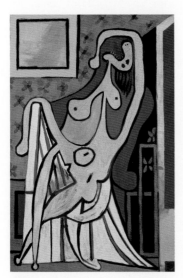

Pablo Picasso
LARGE NUDE IN A RED ARMCHAIR 1929 [70]
Oil on canvas
195 × 130 (76 3/4 × 51 1/4)
Musée Picasso, Paris

Bunny Gets Snookered might be a joke on Picasso as a cliché of masculine aggressive creativity, like an art student's idea of what it is to be up to speed on theory: 'I hate Picasso, I read in an article he just wants to fuck those nudes with his paintbrush', kind of thing. But the humour in Picasso is very similar to the humour of the *Bunnies* – anarchic, without a fixed perspective. In *Large Nude in a Red Armchair* 1929, for example, aggression against women is just as much aggression against Cubism and against tradition and the past. And in any case it's not merely aggression. Picasso's nude is only floppy if you imagine it to be real instead of a constructed thing within a painted thing. To ask a modern popular audience to see a painting as a construction of shapes rather than a literal depiction might be asking too much. On the other hand Lucas, a populist and a serious artist at the same time, says she finds Picasso impressive for the same unproblematic reasons many people do – his ideas and creativity, and the fertility of his imagination.

Even if you don't know anything precisely about Picasso, you do in a way, because everyone does. Just as you can't not be part of your times in a political way.

It's not so much that I concern myself in advance with influences or with precedents, or whatever – the point is when you've got something, you find you recognise all those things in it. They help you realise you've got something there – just that sort of background knowledge.

CHUFFING AWAY TO OBLIVION
1996 [71]
Newspaper, shellac, wood, door,
picture rail, light, lino
281 x 281 x 281
(110 ½ x 110 ½ x 110 ½)
The artist and Sadie Coles HQ,
London

TRY IT, YOU'LL LIKE IT 1999 [72]
Sofa, melons, dried meat
122 x 180 x 122 (48 x 70 7/8 x 48)
The artist and Sadie Coles HQ,
London

BEAUTY

*Torn posters all over boarded-up shops, or all over corru-
gated iron: that's the kind of London I grew up in. And even
being down in the studios in Shoreditch, in the 1980s, it
was very different from the kind of thing it is now – it was
grubby and shabby. London was much shabbier. And that
shabbiness and depressive feel about London has been
around all the time, up to now.*

If Lucas's art were a novel it would be *Money*
(1985) by Martin Amis. London in that book is all
hand jobs, hard-ons, hangovers, massage parlours,
sex shows, slot machines, garages in trash-strewn
mews, and pubs called The Blind Pig and The
Butchers Arms. Punching and head-butting always
follow drinking. Reading is confined to menus,
tabloids and prostitutes' cards – 'Do you dare phone
the Bayswater Bitch?' Tabloids are full of stories about
the Royal Wedding, which bring on childish tears,
and occasional bits about military and political
upheavals abroad, which are seen as extensions of
head-butting. Flats are 'gaffs' and 'lairs' and 'lean-tos',
the purpose of which is to keep paid-for girlfriends for
fucking, nude mags for wanking over, and to have
private tortuous wrestlings in the toilet, brought on
by fast food from Burger Den, Burger Hatch, Burger
Shack and Burger Bower. (Fast food joints in New
York, where everyone in early 1980s London goes to
all the time, are called Blastburgers and Fastfurters.)
Cars are Culprits, Alibis, Iagos (these are black) and
Fiascos. The intersection of nature and culture is
summed up by a vision from a Fiasco of a pigeon
eating a chip.

Lucas's 1990s London is all car parks, garages,
warehouses, snooker tables, unresisting boneless
hopeless Bunny girls, cigarette gnomes and false-
teeth vaginas. Her equivalent of Amis's world, in
which things are always outrageously exaggerated
while grounded in common vulgar reality, is a world

where things are always quite surreal: melon-breasts,
cucumber and marrow penises with testicles made of
ripe oranges; vaginas made of kebabs and kippers, and
of fire-buckets and wire-brushes. Fluorescent tube
penises, beer can penises, fried-egg breasts, and ciga-
rette-covered vacuum cleaners that double as cleaning
ladies with outrageous hanging breasts made of ciga-
rettes. There are grim dilapidated spaces housing
burned out cars, as well as cars coated with cigarettes,
and humping and wanking cars. Shellacked tabloids –
with headlines that shout things like 'Gazza is a
Dadda!' – line the brown wrapping-paper walls of
dingy lairs designed solely for smoking in.

*There are days when I think about where my stuff
comes from, about the world. There are times when I can
get great pleasure from the works I've made, and feel great
affection for them, even for their brutality. There are other
times when it just seems to me as dreary and as paltry as
anyone else might think that something like two fried eggs
on a table is. There are times when it just seems like, you
know – 'What kind of a thing is this to be doing?*

Lucas's art has a particular look, one of drabness
and plainness. In Amis's scenarios, this bleakness is
mere colouring, but with Lucas it's the aesthetic heart
of the matter. Once she showed some things that
were just dismal lists of swear words (fig.73).

*One list was excremental. One was a list of words for
fucking. And one was for blokes – like 'fucker'. But they were
mostly – yeah – 'bad' words relating to men and bad words
relating to women: homosexuals, excrement, and wanking,
and so on. To me the hand-written element was important
– the fact that you only needed a pencil and paper. And you
could find a way to arrange that. And you could actually
give a line a shape – literally a shape on the page.*

As well as playing with the grim, Lucas and Amis
both play with the self. There is a twisted confessional
element to *Money* – twisted because it's a book the

ANIMAL, ASS, BAT, BATTLEAXE,
BEAUTY, BIRD, BIT, BITCH, BROAD,
CHICK, COW, CRACKER, CUNT, DOLL,
DOG, DRAGON, DYKE, FANNY, HAG,
HOOKER, MEAT, MONSTER, MUFF,
OLD BAG, PET, PIECE, PUSSY, SHIT
CUNT, SKIRT, SLAG, SLUT, SMASHER,
SOCKET, TART, TIT, TRAMP, TROLLOP,
TWAT, WHORE, WITCH 1991 [73]
Pencil on paper
23 x 18 (9 x 7 1/8)
The artist and Sadie Coles HQ,
London

narrator, John Self, an advertising executive, could never have written because he's too much of a yob. There's even a character called Martin Amis who might be part of a plot to do John Self in – culture's revenge against the uncultured. The selves in Lucas's self portraits are real but not filled-out enough to be wholly believable. Mainly there's a sense of something deliberately kept back, because of her minimalism: while what is there almost always suggests a deliberately incongruous masculine viewpoint.

Money is social satire in an English literary tradition that begins with Smollet and Fielding (with Hogarth as a visual-art equivalent) and has Dickens as its great figure. But the book also connects to a modern US tradition of outrageous self-examination and self-revelation that has Philip Roth, Saul Bellow and John Updike as great figures. A perpetual compulsive unmistakable twitch of male sexuality runs through this tradition. In Lucas's masculine-looking art, there's a question mark over this twitch, so it can't be taken for granted.

The tradition Lucas is part of is visual not literary. In terms of materials and subject matter and the public's ability to 'read' art, to find it legible, she brings together elements from Pop art, Arte Povera, Joseph Beuys and Jeff Koons. These ideologically very different, sometimes opposed figures and movements are united in their preoccupation with everyday objects. Pop's approach to the everyday is glamorous and sexy, Arte Povera's more freewheeling-poetic, Beuys's more mythological, and Koons's is an extreme version of Pop, with a bit of added deconstruction-hysteria, or deconstructive babble.

Koons stands out in the mix, because of his use of sex in getting avant-gardism over to a large public. He was always on TV in the late 1980s and early 1990s explaining the erotic meanings of objects that appeared to be only everyday kitsch made enormous, or explaining the sacred meaning of objects that appeared to be quite unavoidably outrageously pornographic. The glossiness of his objects had an obsessive quality that made the work seem slightly sick rather than glamorous exactly – and this macabre element both expressed the age and was attractive to it.

Arte Povera ('poor art'), an influential Italian movement that began in 1967 and gradually wound down in the 1970s (but which now has fashionable retro appeal), overlapped slightly with Pop in that it was fascinated by the insignificant, and this included mass-produced stuff – neon, newspapers, photos, and so on. But Arte Povera was against consumerism where Pop was either neutral or celebratory about it, or so ironic you couldn't tell. And Arte Povera is completely opposite in mood to Koons: hippie-transcendental, verging on twee, rather than polymorphously perverse, verging on horrible (fig.92, p.119).

Everything in Beuys's wide-ranging output centres on a single mythological structure of his own invention, a Jungian, Gurdjieffian, Rudolf Steinerish journey of self-realisation with added social improvement and ecology. He exhibited old batteries and food and fat and chairs and newspapers (fig.75, p.99), and attributed symbolic meanings to these materials in shamanistic performance-art events.

The 'poor' materials in Arte Povera were not so grim and dowdy as in Beuys (they tended to be rather fancified by their context – mixed in with marble or ornate picture frames, or arranged according to the Fibonacci system) and there was a much more freeflowing poetic idea of meaning. The down-to-earthness of the one and the looseness of the other are important in Lucas's work, but they have different implications. Her twist on Beuys is that low subject matter doesn't need a shaman to make it mean some-

ANIMAL
ASS
BAT
BATTLEAXE
BEAUTY
BIRD
BIT
BITCH
BROAD
CHICK
COW
CRACKER
CUNT
DOLL
DOG
DRAGON
DYKE
FANNY
HAG
HOOKER
MEAT
MONSTER
MUFF
OLD BAG
PET
PIECE
PUSSY
SHIT CUNT
SKIRT
SLAG
SLUT
SMASHER
SOCKET
TART
TIT
TRAMP
TROLLOP
TWAT
WHORE
WITCH

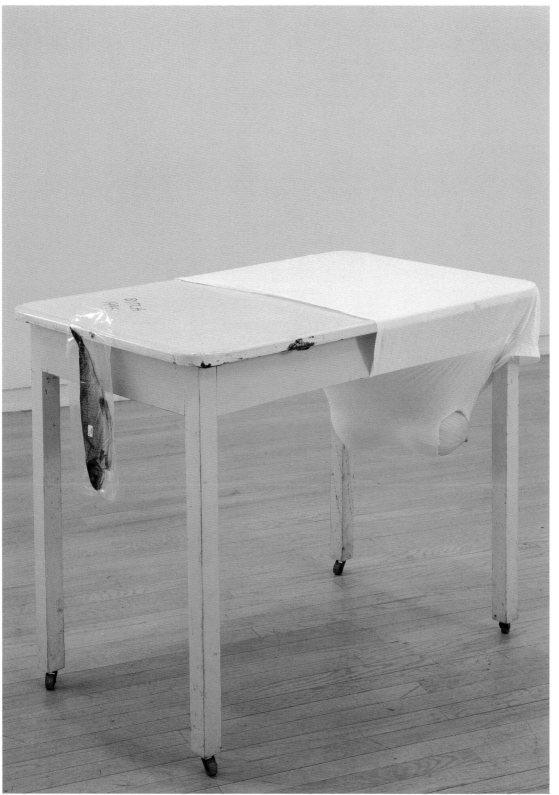

BITCH 1995 [74]
Table, melons, t-shirt, vacuum-
packed smoked fish
31.5 x 25 x 40 (12 3/8 x 9 7/8 x 15 3/4)
Museum Boymans van Beuningen,
Rotterdam

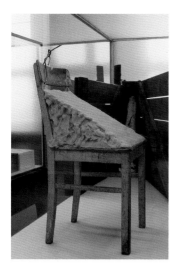

Joseph Beuys
FAT CHAIR 1963 [75]
94.5 x 41.6 x 47.5 (37 $^1/_4$ x 16 $^3/_8$ x 18 $^3/_4$)
Hessisches Landesmuseum,
Darmstadt

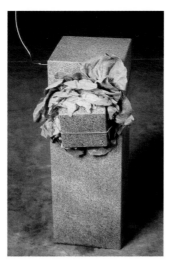

Giovanni Anselmo
UNTITLED. EATING STRUCTURE
1968 [76]
Lettuce, copper wire, granite stones
Large stone 60 x 25 x 25
(23 $^5/_8$ x 9 $^7/_8$ x 9 $^7/_8$)
Small stone 12 x 12 x 5 (4 $^3/_4$ x 4 $^3/_4$ x 2)
Private Collection

thing. And her twist on Arte Povera is that modern art's intellectual complexity can be simplified down to a single principle – art is something that happens in your head as much as in the object in front of you.

As with Beuys, Arte Povera's apparent simplicity was connected to complicated and often mystifying ideas, which needed a lot of explaining. And even then the audience was asked to believe that something obviously not quite wholly feasible, such as spiritual symbolism from another age, was a reasonable justification for a lettuce in a gallery, or a lot of live horses. Or it might be some neon lights spelling out symbolic numbers entwined with twigs, or machine-cut marble mixed with rough rocks. Or it could be a photo of the artist transformed in some absurdly simple way: the eyes replaced by reflective material, or the ears cut off (and then you'd see the ears on their own exhibited later in a different exhibition). Arte Povera revolved around a set of objects that were obviously modern, flimsy and slight, and not really capable of embodying rich mythic structures but only of referring to them by esoteric symbolism – with which only someone who lived their whole lives poetically analysing meaning could really feel comfortable.

Comic inexplicability is always the fate of art in *Money*. But Lucas's equivalent of *Money* actually is art. Any one of her works might be specially made for John Self. For example, in *Bitch* 1995 (fig.74), melons and kippers and a second-hand table make an easily readable sign for a female body, presumably waiting to be mounted. Amis's drunken randy yobbish advertising guy would be able to see what the meaning was, without possessing any special information that only an art buff could know. But he could also see, because of his profession, that what should be obvious and direct has been defamiliarised by some kind of imaginative deconstructive process, and become something else.

We were doing this show in Frankfurt ['Football Karaoke']. *The idea was we'd go over there in buses and do the show. It was lighthearted. I did* Bitch *and* Au Naturel *both at the same time. It was soon after* Two Fried Eggs and a Kebab. Bitch *is much more like a beast, whereas* Two Fried Eggs and a Kebab *is more like a picture, in a way. At the time I needed to have that photograph of the eggs and kebab standing as the head, so it could make sense to me. Also, I think with that work, a lot of people thought it was about two fried eggs and a kebab, and the table didn't particularly come into it, but I don't think that's the same with* Bitch. *It has particular qualities: the way the melons hang in the T-shirt, which make a chest like you'd see on a dog, and things like the quality of the line, which is just something nice. In a way it's very cartoonish but the other side is that the kipper is pretty horrible. And there's that thing of cutting the T-shirt, the cuts in it for the melons, which is kind of brutal. Maybe it's something like what you'd see in pornography, where you actually make something purposefully more rude – which you don't get in some other things I've done.*

Bitch is an aesthetic arrangement as well as a puzzle. The aesthetic effect is identifiable with the individual elements that make up the puzzle but isn't limited to them. *Bitch* conforms to what society demands from culture as a result of the social transformations satirised in *Money*. The direct effect of Thatcherism on culture and art and aesthetics was popularisation: the kind of opened-up TV we now have, with multiple channels instead of just three, all of them quite jokey and ironic and porny, is the result of barriers being lifted because of the free market. TV, the mass media, industry, class, everything, including art, became opened up, according to the same principle of making money flow better. The subtlety of *Bitch* as an object that equally expresses a new ideology and

opposite: CONCRETE VOID AND
ISLINGTON DIAMONDS 1997 [77]
Smashed car, black and white
photographs
Dimensions variable
Installation view, 'Car Park', Museum
Ludwig, Cologne, 1997
The artist and Sadie Coles HQ,
London

offers a critique of it, is something John Self could get, and might even think about plagiarising for one of his ads. It's not that Beuys or Arte Povera are accessible now but that a certain kind of aggressive obscurity has become acceptable. That a work of art should have popularity but also have all the formerly impossible avant-gardism of Beuys and Arte Povera is a sign of the times, but it's also part of Lucas's originality.

I grew up in a working-class background, which has been superseded by an underclass. Class divisions have changed. My type of working-class background is almost a cliché now. But for me it was never a pure working-class experience, because there were always windows onto different things. I can almost remember clocking these different things, finding them odd and interesting, and them breeding in me a kind of open mind. Just by virtue of growing up in the middle of London, there were so many different types of people around. With my dad being a milkman, we used to go into people's houses and meet doctors or architects, and they'd give me a bit of chocolate, and I used to register the surroundings. Even as a little kid I remember seeing things that made me compare different lifestyles and wonder about that kind of thing.

There was art in my family, in a way. My dad used to write poetry and do a bit of painting. When they got bored with the telly they'd turn it off and sit and draw each other. And my mum's massively into crafts and so on. And DIY – all that stuff, we always did.

When I was at college I tried so hard to learn to be a proper artist of some sort, which was useful. But in terms of the work that's associated with me, I was making a lot of things like that even when I was a teenager: doing collage, hanging Coke cans on strings. And even when I was a tiny kid I used to unpick wool and make it into fluff. I always liked the textures of things. Even if I had a job and didn't think about art, I'd still do those things around the house, just because that's what I'm like.

There was always somebody banging away at something. My dad used to make bits of furniture in the house. It would suddenly become fashionable in the 1970s to have something to put your stereo on, and he'd do it but he'd always get the scale wrong and make everything too big. And our mum used to make our clothes. It was partly just being hard up. I was always sewing my jeans to make them tighter here or there. And I think a lot of the urgency about making things, for me, comes from not having the right stuff and it being kind of urgent to your credibility to get it somehow – you know you need it and you're going to have to make it yourself.

In 1999, Lucas was gathering objects for an upcoming show in Germany. She thought one of them might be a car. She set off with the gallery owners to the scrapyard, and on the way they got stuck behind a car full of Croatian gangsters in white polo necks, dripping with gold jewellery. It had a sticker on it that said 'No Limits', so she borrowed it and fixed it on the window of the wreck she eventually chose.

The temporary exhibition space was lined with exposed pipes. There was harsh fluorescent lighting and pale green walls. The objects included a vacuum cleaner coated with cigarettes, with a pair of cigarette breasts hanging in a bra from the curved-over vacuum pipe. This was called *It Sucks* (fig.78). There was also a self-portrait photo (*Beautiness*, fig.79), with the same title as the exhibition. This showed Lucas smoking a cigarette and holding a pair of cigarette breasts (actually cigarette-coursed rugby balls) against her own chest. And there were several wanking arms. One called *Pig-u-wanker* was mounted on the wall on a bit of wood – a light touch and the wanking gesture springs into action. Another was fixed in the driver's seat of *No Limits!* (fig.81), and another was in a wooden box, with a mirrored interior. From a distance it was a plain box. Peering in, you saw an

IT SUCKS 1999 [78]
Vacuum cleaner, cigarettes, foot-
balls, bra
139 x 100 x 80 (54 3/4 x 39 1/4 x 31 1/2)
Private Collection, London

opposite: BEAUTINESS 1999 [79]
R-type print
129 x 90 (50 3/4 x 35 3/8)
Barbara Gladstone Gallery, New York

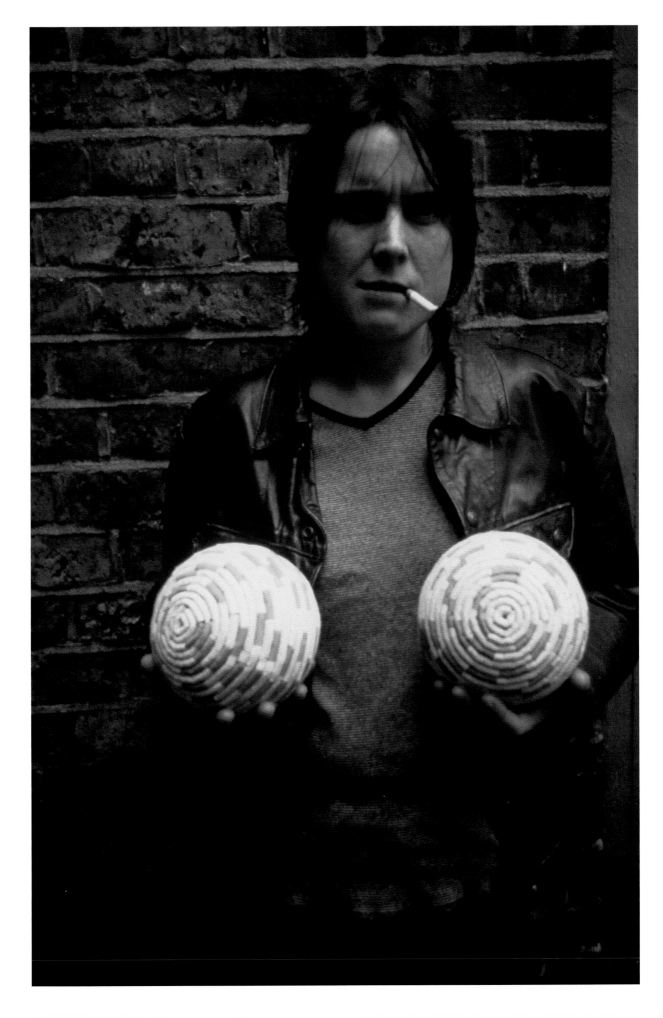

WANKER 1 (SARAH) 1999 [80]
Fibreglass, acrylic, wood, steel spring
32.5 x 15.5 x 61 (12 3/4 x 6 1/8 x 24)
Nick Silver, London

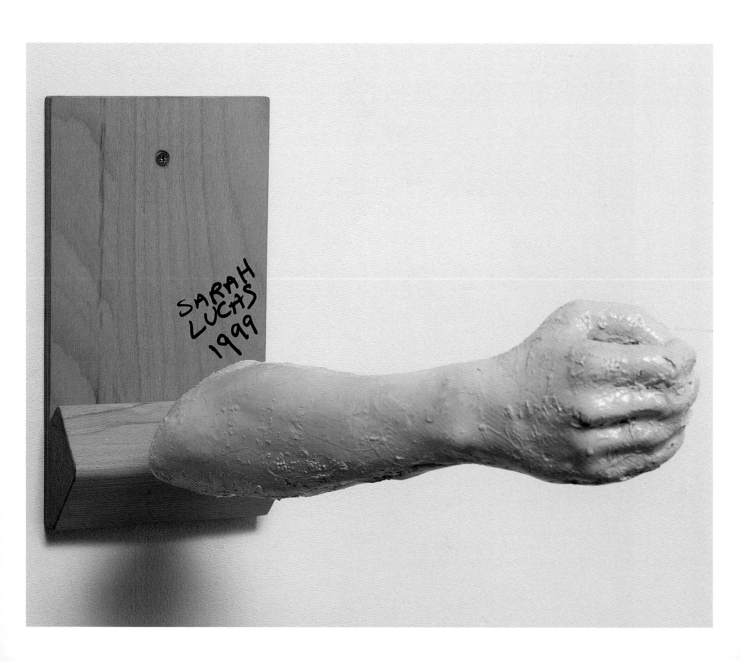

NO LIMITS! 1999 [81]
BMW car, fibreglass, electric motor
148 x 180 x 460 (58 1/4 x 70 3/4 x 181)
Installation view, 'Beautiness',
Berlin 1999
Private Collection, London

infinity of arms wanking in all directions, in unison, like a gigantic dance (fig.83). A fourth was in a bedroom-sized cube made of cardboard. The interior could only be viewed through a small hole. Inside you saw linoleum and unpleasant wallpaper. A light bulb dangled over a couple of beer crates, upon which was an arm masturbating mechanically over a hard chair. This was called *Bigger Cheaper (and you can do it at home).*

Wanking arms was an idea I'd had knocking around for a long time. I'd actually cast an arm for it, which got used instead for that piece One Arm Bandits (Mae West) [fig.61, p.80]*, in 1994. The stumbling block was that it seemed too silly an idea to justify the aggravation of working out the mechanics. But in 1999 I had this show planned, 'Beautiness', and as it approached I still didn't have a lot of ideas, so I trawled through what I could remember of the old ones and there it was. I turned up with three arms roughly made in cast fibreglass. I worked on the show for a couple of weeks, with someone else sorting out the mechanics. My feeling is that wanking is all about time. Sex in general is time, literally – the wanking arm looks and feels and sounds, in the head, like a clock. It's always going on. Somebody else takes over where you left off. It's like a tune that we all have some inner compulsion to sing along to. So the mirror effect was a way of doing something that suggests infinity. It's called* Wanker Destiny*, or* Wichser Schicksal *in German* [fig.93].

'Beautiness' was put on in Berlin but it might as well have been London. The feeling was of being in the back of a garage, with all sorts of imagery on thrownaway newspapers, or hanging from the wall, maybe pin-ups in a calendar, and all that being the raw material from which to draw ideas for artworks. As objects they had to have the same what-you-see-is-what-you-get straightforwardness as functional crap in a garage.

It could have been more than just the arm: a whole couple having sex. But, apart from the fact that this didn't occur to me, it wouldn't have been as good. For a start, it would have been sensational and trite and looked artificial, as dolls and models always do. And another thing: the arm is real size, and a real-size copulating couple would be overblown and pretentious and have none of the dreary quality that the outside of a smallish unpainted box has.

In Lucas's work beauty might be the beauty of the ordinary, the beauty of something being aesthetically right, or the beauty of hidden laws that make systems work. 'The Law' was the title given to an earlier exhibition that ran along the same lines as 'Beautiness'. The venue was the shell of a factory in Clerkenwell, in east London, in the process of being converted into flats. It was 1997: just on the wrong side of the fashion for putting art shows on in warehouse spaces. But it was possible to accept a bit of theatricality anyway: real rubbish and dilapidation appropriated as staged dilapidation.

The show's title recalled *The Sweeney*, in which everyone is a bit shabby and either on the run from the law or they are the law. Objects lay about, with a lot of rough gloomy space between them. A bath was in the middle of the floor. There was a wooden structure with brown paper walls, a jacket on the back of a chair, and a TV set. Somewhere else there was a car. The largest work was a kind of painting that might in fact approximate to a kind of pin-up: the self-portrait photo *Fighting Fire With Fire* (fig.45, p.58), repeated twenty times at full scale, drizzled-over with a lot of thin paint, renamed *Fighting Fire With Fire 20 Pack* 1997 (fig.46, p.59). The car was a humping gold Ford Capri, called *Solid Gold Easy Action* 1997 (fig.82) installed with hydraulics to make it seem as if a couple was having sex within. The white enamel bath lay over

SOLID GOLD EASY ACTION 1997 [82]
Ford Capri, hydraulic pump
133 x 167 x 439.5 (52 3/8 x 65 3/4 x 173)
Installation view, 'The Law',
London, 1997
The artist and Sadie Coles HQ,
London

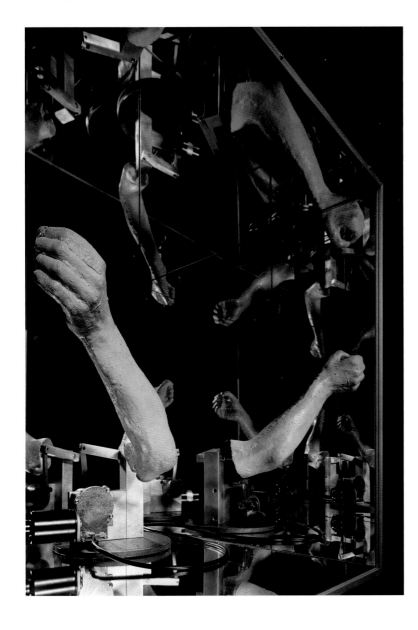

WICHSER SCHICKSAL
(WANKER DESTINY) 1999 [83]
Wood box, mirror, and mixed media
64.5 x 59.5 x 63.5 (25 $\frac{1}{2}$ x 23 $\frac{1}{2}$ x 25)
Pitrowski-Ronitz Berlin
Courtesy Contemporary Fine Arts,
Berlin

a body-sized flesh-coloured puddle on the floor (*Down Below* 1997). The jacket was Lucas's own jeans jacket, familiar from photos, remade in brown paper (*Auto-erotic* 1997). The brown-paper walls turned out to be a chamber for smoking in, called *Chuffing Away to Oblivion* 1997 (fig.71, p.94). Its interior was lined with tabloid spreads coated with shellac, so the room seemed nicotine-soaked. The TV was concrete, with the words 'The Law' carved into the screen, as if television is where the law of everything comes from – and it's set in stone.

When I come home in the early hours and I'm trashed, I look at newsagents, and the Benson & Hedges signs, and all the pasted-over stuff on the posters, and I look at the litter, and I think, 'Christ! If there's going to be a world and we're going to be alive, and we're going to be conscious of ourselves, why on earth is it like this? Why is it shabby?' But it is, and there's a kind of hilarity to that and, in a way, beauty.

When I first started using cigarettes in art it was because I was wondering why people are self-destructive. But it's often destructive things that make us feel most alive.

This work was first shown in a gallery in New York. At the time it was the largest sculpture Lucas had done. Two cars were acquired from a scrapyard, each one partly burned-out. She lined the front interior of one with cigarettes, and did the same with the exterior of the other. A burned-out car suggests pollution, waste, death, destruction; cigarettes might also represent self-destruction. Having an inside and an outside suggests different points of view onto a single thing – given the context of Lucas's history as an artist, it might be a body, although there isn't a direct sexual theme. The title suggests lungs destroyed by smoking, and also that life might be a process of self-destruction – if it isn't through smoking it will be through something else. The objects make a dramatic impact just by virtue of their size, their surfaces (complicated by the cigarette-appliqué) and their smell. The cigarettes don't necessarily demand to be interpreted. They're a careful addition to an already rich visual texture – blackened metal, shattered glass and burned upholstery.

If you're walking along and you see a house that's on fire or one that's been recently burned, with burned-out windows – or even if you see a burned-out car – there's something really effective about it.

The use of cars is just because I wanted to do something on a certain scale. I generally do things that are quite small. I was confronted with this space in New York for an exhibition, so I thought I'd better get something really quite big for it. So I went to look at cars. There were certain things I had to take into account – the way the bonnet was smashed up, and so on. But as well as that I wanted a couple of cars that were typically American. Then when you start looking, suddenly what you imagine to be typically American goes out the window, and other things come into it – like exactly how burned-out it is. I didn't find any that were burned quite enough, so I got someone to burn them much more. And I wasn't going to use something too smashed-up, because again that affects the form quite a lot.

overleaf: LIFE'S A DRAG (ORGANS) 1998 [85]
Two burnt cars, cigarettes and glue
Each car 146 x 460 x 180 (57 1/2 x 181 1/8 x 70 7/8)
Installation view at Barbara Gladstone Gallery,
New York
Fondaziona Prada, Milan

I'd always had it in mind to do something about the fact of smoking. I wanted to make something about the heart and lungs. At first I wanted to do it in real size – the size of lungs – but it was too complicated, because you can only bend cigarettes so much. And then in the meantime I started using cars a bit. The first time I used one was for 'The Law', the year before this work. But in this case I liked the idea of the cars being burned-out, because of the parallel with lungs. And I liked the idea of having two of them, again because of the two lungs, and because of people's idea of lungs as something insulated from the outside. Cars insulate you from the outside, like a home does – it's shocking if it's violated.

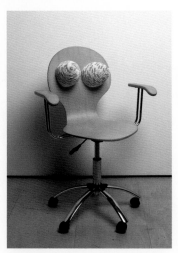

ORAL GRATIFICATION 2000 [84]
Office chair, cigarettes, rugby balls
95 x 68 x 58.5 (37 3/8 x 26 3/4 x 23)
Gregory Papadimitriou, Athens

A whole series of cigarette-coated objects started emerging about this time, culminating in 'The Fag Show' in 2000 – this included cigarette-coated gnomes and vacuum cleaners, a cigarette-coated life jacket ('death' and 'life') and a chair with cigarette breasts. There were also intricate self-portrait line drawings about four feet high on brown paper, with the lines made up of cigarettes. The gnomes were little grotesque sex objects, since they had joke masculine titles – *Willy* and *Nobby*, and so on – and a single non-coated gnome could be seen in the background of a self-portrait photo in the exhibition, showing Lucas wearing a T-shirt with the slogan, 'Selfish in Bed'. The gnomes also might have symbolised false sweetness, or escapism, in a context of death – death being suggested by cigarette-breast wallpaper and by the predominant black and white colouring of the show, varied only by the occasional beige and brown of wood, parcel-paper and cigarette filters.

Whereas *Life's A Drag (Organs)* (fig.85) was about breaking new ground with new materials and a new subject, the work in 'The Fag Show' was about going over earlier themes with a new technique, so that old meanings were now recast – like a painter going back to the same landscape but with new formal ideas. What would it mean to have a cigarette dwarf instead of a dwarf in the *Sport*, or to make a picture of yourself in the form of a kind of laborious cigarette embroidery, rather than taking a photo of yourself smoking?

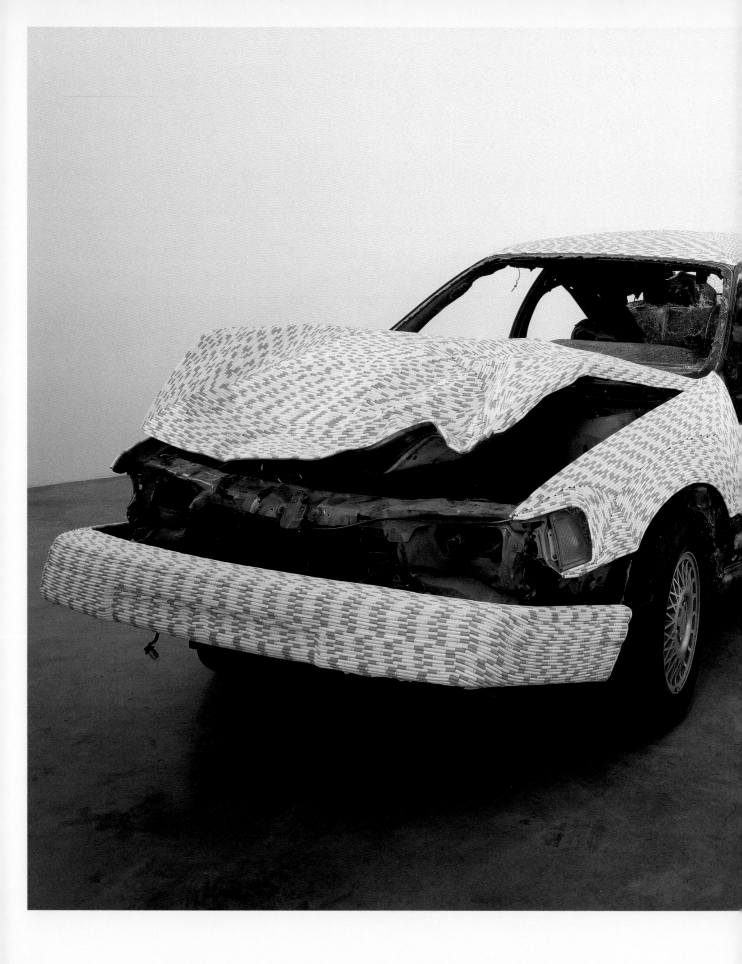

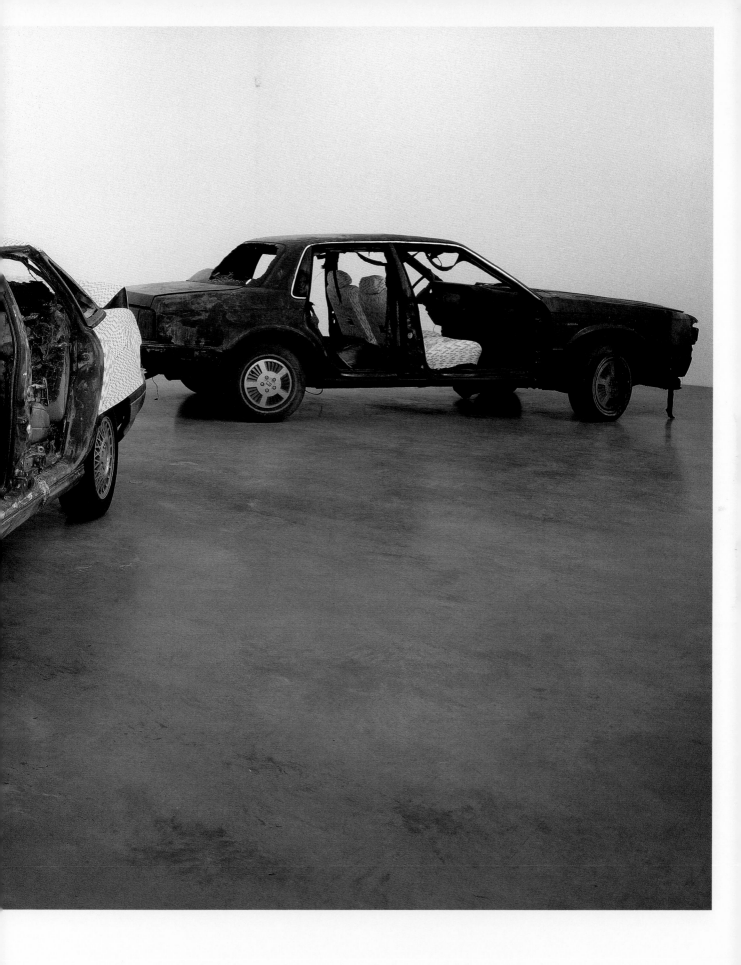

What's always interested me is the animosity people have towards art. They hate it and think it's crap but that's part of them appreciating it, in a way. They want to have that thing there in order to knock it. That's what's required, really, even that confusion about its real value – because there's always got to be something that questions values.

One night in November 2001 I went round to Lucas's place for dinner. Everyone shouted at the top of his or her lungs. It was a semi-detached house in north London and we all gathered in the bright small kitchen/dining room on the ground floor. It must have been the knowledge that Lucas was working on the sets for Michael Clark's ballet, mixed with the feeling of unreality caused by everyone's grandstanding, but I fantasised that they were all important cultural figures, successful artists and novelists, or involved with ballet or poetry. It was like a rediscovering of the satirical eighteenth century, with modern names. I thought the writer Gordon Burn looked like an eighteenth-century author without his wig, as he interrogated me at top volume. Several shouted conversations went on at the same time. It seemed more and more like an act in a comedy or a light opera – 'Art and Society in an Age of Incommensurate Value-Systems.' One thread was that a well-known monster of the British art world was Osama Bin Laden. I understood another to be that Osama Bin Laden was Andy Warhol. I said to an English art dealer, who lives in New York, 'Oh you mean Osama's like Gandhi but just not for peace?' And she replied, 'How do you know he's not for peace?' Then Lucas came into the kitchen pulling her jeans up, having just come from the toilet, laughing and repeating in loud guffaws a phrase she'd just overheard me coining: 'Great bores of the art world! Great bores of the art world!' She told the artist Angus Fairhurst to sit in my lap – 'You're a

Silly Billy!' he shouted. All the guests drank furiously. The only one who didn't was Sadie Coles, Lucas's London dealer, whom I now saw was well brought-up and pleasant, like the daughter of someone posh and military or posh and religious.

There'd been an article about Lucas in the *Observer* magazine by Lynn Barber a year or so before, with a cigarette self portrait on the cover. The article was called 'Drag Queen', a witty conflation of Lucas's cigarette theme and her theme of gender (fig.87). In it you learned she'd been in the six-figure income bracket since about 1997, her work has been bought by major museums around the world, and when it comes up at auction it can fetch up to £135,000 – this is what was paid for *Fighting Fire With Fire, Six Pack*. An early self portrait had recently sold for £120,000 at Christies. When I read this, I reflected that the public in Britain had really only recently become fascinated by contemporary art; it still didn't know how to evaluate it – it must have wondered how prices connect to value. Were they arbitrary or did they mean something?

Hours later, gliding up to Holloway Road in my £300 magenta Ford Fiesta, and absent-mindedly admiring the wonky composition made on the side window by a row of peeling old Pay-and-Display stickers as it came into view occasionally when my head lolled, I thought how Lucas wanted to convey the texture of modern life in her art, but how she also wanted to be an agitator, to be against the grain.

I hadn't yet started the interviews for this book. When they eventually got going, one of the things she often said was that she was exhausted from doing shows where she'd just hit the town, wherever it was, buy up stuff in junk shops, and then make it into art right there in the gallery. The most recent of

Willliam Hogarth
A MIDNIGHT MODERN
CONVERSATION *c.*1732 [86]
Oil on canvas
76.2 x 163.7 (30 x 64 ½)
Paul Mellon Collection,
Yale Center for British Art.

these had been 'Self Portraits and More Sex' (2000) in a big public gallery, Tecla Sala, in Barcelona.

As well as her set of reprinted self portraits, the exhibition featured a lot of sculptures. They seemed like a baroque re-doing of earlier themes, with new formal orderings that were more extravagant and playfully careless. Titles like *Cock-a-doodle-do*, and *I might be shy but I'm still a pig* – the first for a work featuring a chicken with a fluorescent tube up its arse and the other for the back end of a smoked ham wearing a pair of underpants – suggested equally confidence and chaos (figs.90, 89).

I wondered how contexts in which her art is seen make a difference to what the art is considered to be. I wasn't just thinking about the changing geographical context as she jets between international art hotspots, putting on shows at venues that are more or less the same anyway. I was interested in the different ways the art might be defined according to, say, the broad social context versus the narrow trendy art-world context, or the perspective of the general public versus the perspective of the academic art-critical world.

She never said anything in our interviews about her intentions that might freeze out any of these different audiences, while never saying anything either that might pin a particular meaning down. She wanted everyone to have whatever idea they liked about what she did. The personal context – her own sense of herself – was interesting but she wanted you to know that it was no more important or finalising than any other way of getting a bearing.

I never like asking anybody for anything. So therefore I developed into an independent person. I didn't feel I fitted in so well. I didn't speak until I was three. I don't know what came first, the shyness or not wanting to ask for anything. When I look at things in retrospect – and I'm sure

I actually felt like this as a little kid – I was always one of these people who feel too much responsibility. I think I must have been praised for not asking too much for things. It must have seemed good to be like that.

There are big age gaps between me and my brothers and sisters, so we were never that close – close in a way, but it's not as if we see each other much or share the same friends. I was close to my parents and I'm still close to my mum. For a long time for all of them I was like a poor relative. They were fine about what I was doing, thought it was good, but wouldn't want to do it themselves. And it always appeared to them that the price of me doing it was that I never had anything. I didn't care because I didn't want anything – I wasn't bothered.

All the rest of my family, before they'd get married, they wouldn't leave home unless they had a washing machine in place. Whereas I didn't care if I had secondhand things, or whether I had anything at all. But for a long time that seemed like the price you pay for your freedom – a lack of material things.

I still get on with my family. It's not hard at all for them to get what I do. My mum gets it very well – she can give a really funny synopsis of what it is. I think she finds some of it excruciating and she doesn't necessarily want all her friends to know, but at the same time she's not all that bothered. She never asks me any questions about it. She gets it and even likes it but I think at the same time she truly doesn't like it because it rubs up against her background, her values and her sense of what's decent and what isn't.

The new popular audience for art sees contemporary art in terms of mythologies of older modern art, as a continuation in a present-day context of modern art's theme of enlightened progress. An insider sees contemporary art's black heart more – and Lucas's work, with its playful cruelty, appeals to that perception. But it appears different from it as well, because it

Lynn Barber article from *Life*, the *Observer* magazine, 30 January 2000 [87]

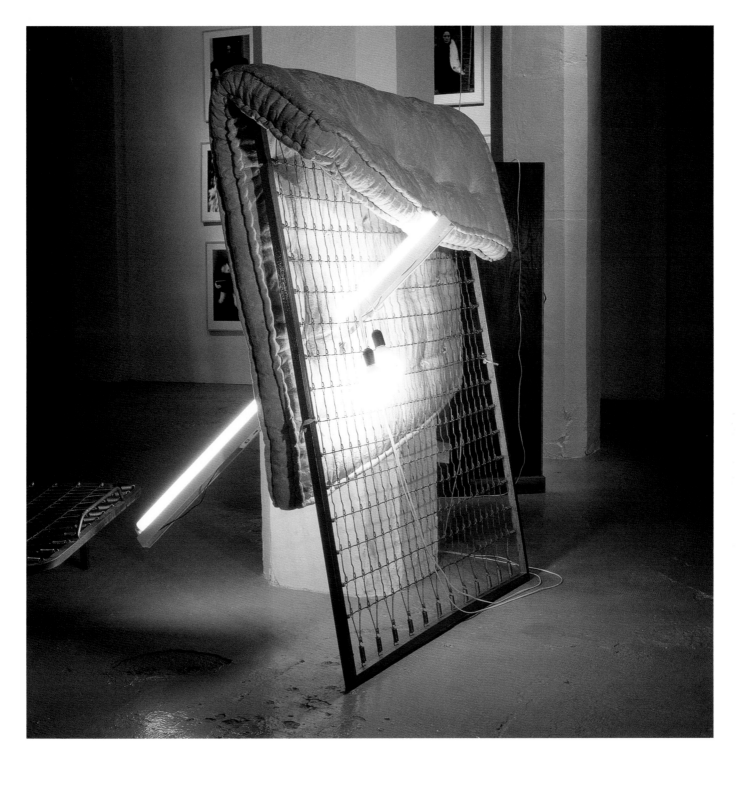

HOW WAS IT FOR YOU? 2000 [88]
Bed-base, mattress, fluorescent
lamps, lightbulbs, electric wire
Installation view, 'Self Portraits and
More Sex', Tecla Sala, Barcelona 2000
185 x 154 x 120 (72 7/8 x 60 5/8 x 4 3/4)
Collection Adam Sender, New York

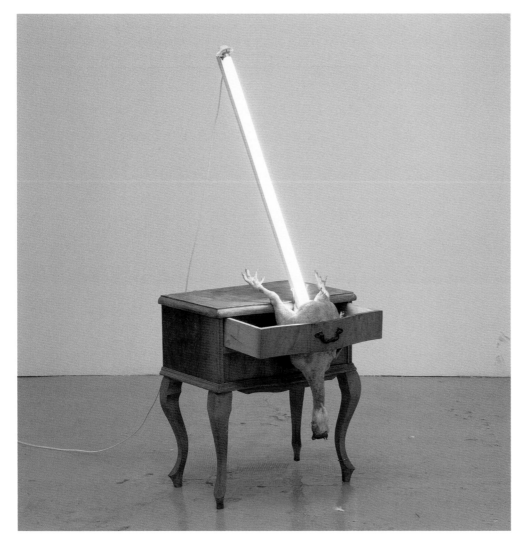

I MIGHT BE SHY BUT I'M STILL A PIG
(detail) 2000 [89]
Mattress, ham, knickers
39 x 190 x 100 (15 3/8 x 74 3/4 x 39 3/8)
Private Collection, London

COCK A DOODLE DO 2000 [90]
Chicken, bedside table,
fluorescent tube
150 x 50 x 55 (59 x 19 5/8 x 21 5/8)
Artvest Limited

seems so direct and so unconcerned with covering a lot of theoretical bases, or with worrying about anticipated criticism on political grounds.

The main difference between the public context and the trendy art-world context is that an art-world insider has a complicated idea of contemporary art, in which there are a lot of oppositions and tensions. And one artist's work is always read in terms of another's, often in a relationship of antagonism. In this mindset art is like hell – full of perpetual squalid bubbling struggle and frustration. The general public's idea of the kind of art that is produced out of this mindset – which certainly includes Lucas's art – seems strikingly simple by comparison. The only tension is likely to be about incomprehensibility versus legibility. And this tension is resolved as the public gets a bit more educated about art, through newly arisen popular institutions like Tate Modern and the Turner Prize, which answer the public's need for clear information.

It would be months yet before I would walk round Lucas's show at Tate Modern, and when I did I was surprised that I hadn't noticed before how prominent the body theme was. 'Heather, have you seen that? It's disgusting!' – this is the kind of comment I overheard from the audience. They'd see how things fitted together and then they'd get what it was they were looking at – 'Oh I get it'. If they were furious, they'd go up to the guards and question them – 'That's meat, isn't it?'

What on earth had I thought her work was about before? I'd always thought its grimness was the main thing – the combining of a grim tone with a pared-back look. That harsh something-deliberately-missing aspect of modern art, which anyone, regardless of his or her art education, recognises and is often repelled by at first, had been deliberately brought out and emphasised so that it seemed to be something in itself, recast and newly noticeable.

I remembered when I heard she'd shown two fried eggs and a kebab in a shop in Soho, it never occurred to me that a reference to the human form would be necessary for the gag. As an idea it seemed enough of a comment on futility to have made a sculpture out of those materials. What did I care about the body in art? When I saw her bits and pieces in 'Penis Nailed To a Board', I thought they were funny, although they weren't exactly jokes. Humour made them accessible initially, and behind the humour they were experiments in coming up with a bleak, lowest-common-denominator idea of what it is to be human.

I reflected now that I was right to free-associate the name of Andy Warhol at Lucas's dinner party, because he is Lucas's predecessor in terms of directness, or a kind of tabloidisation of meaning. Where he has photographic imagery, she has sex. Each explains itself and doesn't need an expert to unravel it. At the same time, for various reasons, her work always has a jarring atmosphere. If its social context were one of new freedoms, where a new openness towards sex was linked to all sorts of socially progressive breakthroughs, her use of sex might be seen as prescriptive – 'Be more sexy!' – or mirror-reflective – 'It's great that we're like this now!' In fact, this new openness to sex in public life, which has been with us in Britain since the 1980s, is not progressive but strange. Lucas's art expresses this, and because it does so she's become a sign for the public of a profound social change.

Sex in ads and in the media now has a giddy, alarming aspect to it. It's clearly connected to the liberal values of the 1960s, but also clearly a distortion of them; part of hypocrisy rather than a challenge to hypocrisy. In Lucas's use of sex in art, the idea of

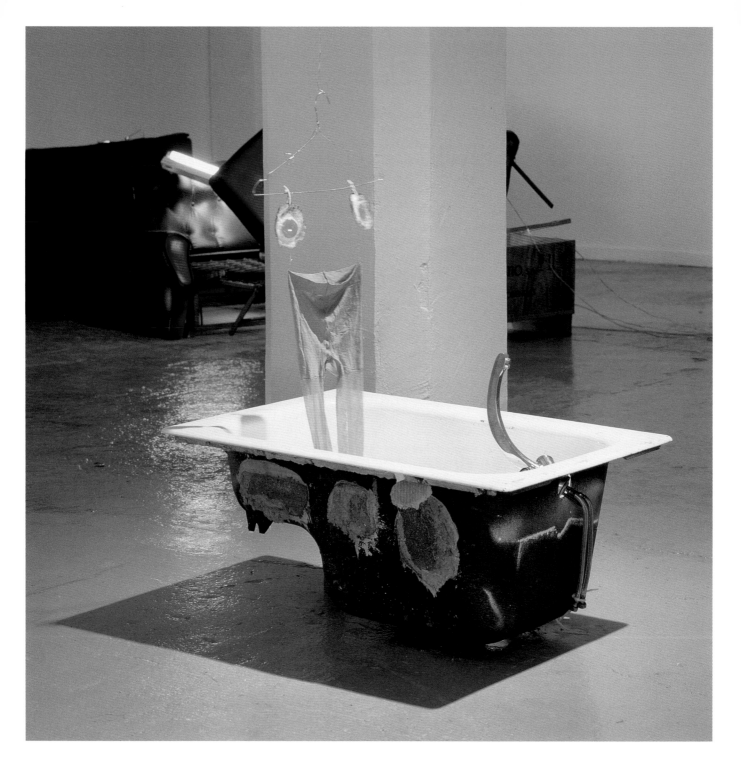

manipulation is transparent rather than hidden, so the feeling of being manipulated becomes part of the content of the work – it's inflects the work's cartoon aspect and gives it its morbid character.

In the public imagination Lucas's work is seen as being about sexual shock – she wants to be a shocker. And the public tries to fit that with what it knows about the history of modern art. Actually the work expresses unease about sexuality, if only because it encapsulates a worldview – a feminist approach critical of women's position in modern art – which is all about unease.

One of the works in Lucas's Barcelona show (fig.91) featured male and female figures in a bath – the female represented by a pair of real fried eggs suspended on a wire coat hanger, and the male by an upturned bath tap. The title, *Woman in a Tub*, was a knowing reference to a work with the same title by Jeff Koons of 1989 (fig.92). Only art-world insiders might be expected to recognise the allusion. Such an insider might smile (maybe a bit grimly) at the way the appropriated title sets up a lot of contrasts, causing meanings to bounce back and forth between the two works. The Lucas isn't exactly the opposite of the Koons; it draws on it in a way that doesn't confirm it but doesn't deny it either.

In the Lucas a female faces a male. Or since the title suggests there's only one figure, maybe the tap isn't a male but some kind of dildo – but that would make it 'male' anyway. In Koons's work, a woman in a bubble bath holds her hands over her breasts; her mouth is open in an O-shape – like the mouths of rubber sex dolls – and the head is cut off just above the mouth. (It doesn't need to have any brains.) A phallic snorkel approaches – the woman gasps in what is presumably a mixture of fear and happy expectation.

Koons's *Woman in a Tub* appears to be the product of a sick imagination, like a scene from a porn film that takes the form of children's cartoons – only the scene has been lavishly realised in three dimensions. Lucas's *Woman in a Tub* is like a parody of a totemic modern-art sculpture from the 1950s, but with the intellectual meanings that would usually be employed to explain such a thing – alienated modern man, ban the bomb, suffering individual in a mad world, and so on – deliberately made impossible. The work defies that solemn existential level of interpretation by demanding to be seen in the most obvious way. It is what it clearly is: a cartoon symbol for sex that anyone can read.

Koons's sculpture, made by Italian and German craftsmen under his direction at huge expense, relies on a different type of cartooning, on a kind of universal ideal of Disney animation. The look is antagonistic to modern-art tastefulness, to the way modern art relishes distressed or impacted surfaces. The look of Lucas's sculpture is a bit more continuous with this kind of modernism. The materials are rubbish but there is a visual richness in the play of different colour-textures: the rubbery real eggs, the dull wire and chrome, the smooth ceramic interior of the bath, the Polyfillered holes with their wipings that read as gestural and painterly. In terms of aesthetic principles the work is an unlikely combination of Salvador Dalí and Jean Dubuffet (figs.93, 94).

For Koons, the idea in being outrageously crass was that art had become weak and must be made strong – and he was going to be the hero of making it as strong as ads and the media. In an interview in 1989 he said: 'I believe in advertisements and media completely. My art and my personal life are based in it.' This would just be Koons's nuttiness and PR

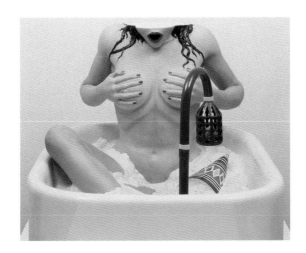

babble if it wasn't for the impact his work had on British art in the late 1980s.

His ads in the art press for 'Banality', the show of sculptures that included the original *Woman in a Tub*, featured high-class studio-lit photographs of himself looking handsome, groomed and glossy. The set-ups included a close-up of his own smiling face next to that of a live pig, as well as a glamorous pool-side scene where he is seen with a couple of performing seals and some sexy women in bathing suits. Another shot showed him in a classroom full of delightful tots, as if taking a lesson, while on the blackboard in the background the content of the lesson could be clearly seen in the chalked phrases, 'Exploit the Masses' and 'Banality as Saviour'.

All these scenarios were provocations by Koons, mischievous tweakings of modernism's theme of progress, where formal radicalism is supposed to correspond to social progress and good values, and if a cultured elite entertains a few abstruse and difficult concepts these will eventually filter down to benefit everyone else. The new thought, Koons was saying, is that both ideals of progress – artistic and social – had long since died away, because both were too much to ask of people. Only lip service was paid to them now, and even that was either dying out or else had become the province of art-department theorists – and who cares what mumbo jumbo they spout? The idea of a 'good' cultural elite was out too, replaced by a moneyed elite, which didn't have to be good as well as rich, because being rich was good enough.

Lucas's *Woman in a Tub* doesn't need the reference to Koons, but in appropriating his title – and perhaps also referencing his pig theme with a pig of her own, in the same show – she points up something important that they share: their equally complicated but differently expressed relationship to good taste.

It's been a long time since an abrasive surface in art automatically stood in anyone's mind for an abrasive attitude. But this is the texture Lucas gives to her literal representation of a particular type of modern wretchedness, a state of mind personified. In feminist studies the female form is looked at for the way it refuses to be a sign in a narrative of masculinity. (The roles given to it in this narrative are always derogatory in some way.) So in this formula Lucas is successful in reinvesting abrasive surfaces with cultural abrasiveness.

The art-historical memory triggered by Koons's classroom scene is of Joseph Beuys, in particular photos showing Beuys lecturing – there would always be blackboards covered with his symbols and diagrams. If Warhol-art is working class, Beuys-art is middle class – it needs explanation and the explanation is always about a do-gooding notion of content. In the popular appreciation of Lucas's art there is a combination of a bit of Warhol with a bit of Beuys. The explanation offered is usually that she explores gender representations as they are found in the tabloid media and in art history, as well as in street slang and everyday language and imagery. Exploring these things is considered to be something delightful, like exploring ways to promote ecology or helping to stop racism and sexism in public life.

Approaching my own street finally, the dawn coming up, I thought of Lucas's status as a popular figure: she's been on advertising billboards (fig.95) and she's always part of an automatic list in popular journalism about art – 'Damien Hirst, Sarah Lucas,

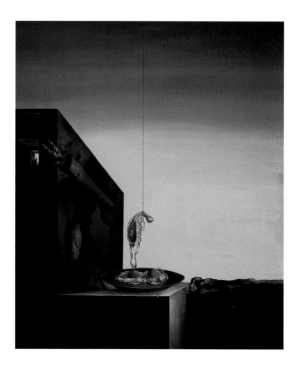

Salvador Dalí
EGGS ON THE PLATE WITHOUT THE PLATE 1932 [93]
Oil on canvas
66.3 x 41.9 (23 3/4 x 16 1/2)
Collection of The Salvador Dalí Museum, St Petersburg, Florida

Tracey Emin, Gary Hume…' But I also saw her as part of an art-historical tradition. She brings her own aesthetic to a modern popular context. The new popular audience for art isn't yet as interested in the aesthetic dimension as it is in meaning – the new audience's definition of meaning being a kind of dutiful ticking off of a list of social issues. Actually this is the same position on meaning that the academic side of contemporary art criticism has recently arrived at, and which causes a typical critic of this kind (because such a critic has forgotten, or never knew, how to see the physical manipulation of materials in art as something meaningful in itself) to occasionally misunderstand Lucas as merely decadent.

But it's the play of surfaces in her art, and her different ways of making things, that show her seriousness. The roughness, minimalism, wonky neatness, low-key colour and subtle contrasts of texture all make the work distinctive. From this point of view her agitating, her nihilism and her punkiness are like Dubuffet's 1940s and 50s *Art Brut*. He is primitive in order to challenge false or empty sophistication, and she is rough and obscene for the same reason. Her social dimension, the feminism of her work, is a modern equivalent to his social dimension: he wants to be anti-taste with a loaded, pointed, anti-charm, in a way that eventually creates a new taste. And in both cases the work is always something more than the rationales that make it tick. As Lucas's art develops, it's clear her subject matter is narrow – at least, it doesn't change much. But her animation of it is unique and rich, constantly presenting its various audiences with something they really haven't seen before.

Jean Dubuffet
MONSIEUR PLUME WITH CREASES IN
HIS TROUSERS (PORTRAIT OF HENRI
MICHAUX) 1947 [94]
Oil and grit on canvas
130 x 96.5 (51⅛ x 38)
Tate

This is Modern Art
Billboard commission for
Channel 4, London 1999 [95]

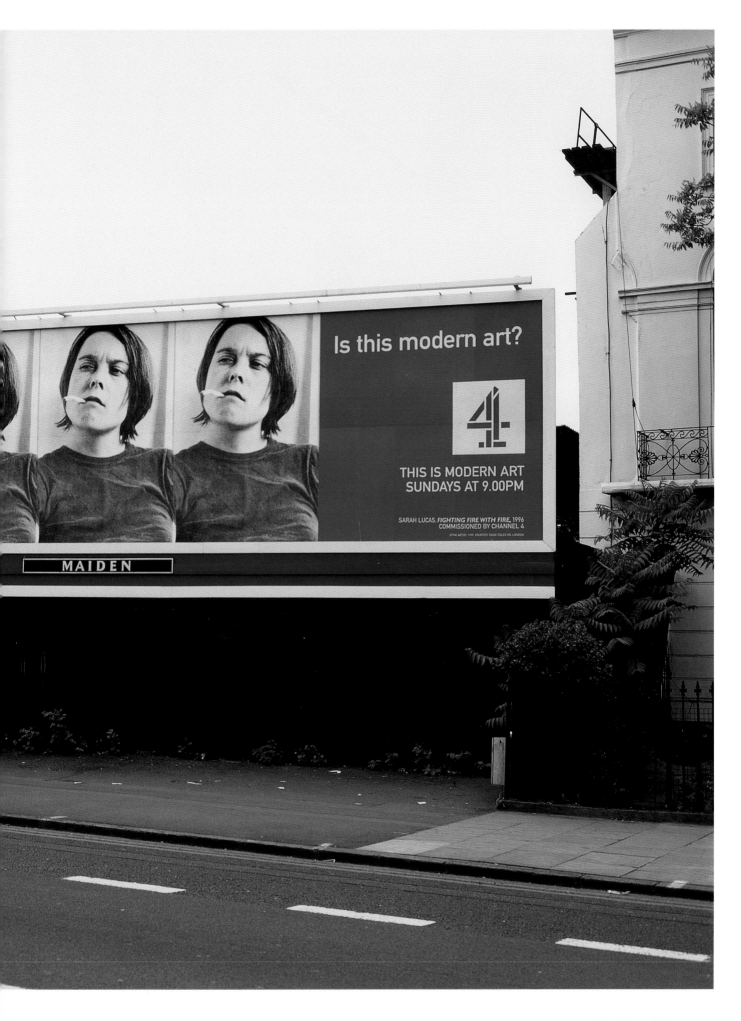

Biography

1962 Born in London
1982–83 Working Men's College, London
1983–84 London College of Printmaking
1984–87 Goldsmiths College

1978 2000 [96]
Black and white photograph
152.5 x 101 (60 x 39 3/4)
The artist and Sadie Coles HQ,
London

Solo Exhibitions

1992 *Penis Nailed to a Board*, City Racing, London

The Whole Joke, Kingly Street, London

1993 *The Shop* (with Tracey Emin), 103 Bethnal Green Road, London

1994 *Got a Salmon On (Prawn)*, Anthony d'Offay Gallery, London

Where's My Moss, White Cube, London

1995 *Supersensible*, Barbara Gladstone Gallery, New York

1996 *Sarah Lucas*, Museum Boymans van Beuningen, Rotterdam. Cat. texts by Chris Dercon, Angus Fairhurst, Jan Van Adrichem.

Sarah Lucas, Portikus, Frankfurt

Is *Suicide Genetic?*, Contemporary Fine Arts, Berlin

1997 *The Law*, Sadie Coles at St Johns Lofts, London

Bunny Gets Snookered, Sadie Coles HQ, London

Car Park, Ludwig Museum, Cologne. Cat. text by Yilmaz Dziewior.

1998 *Odd-bod Photography* (with Angus Fairhurst), Sadie Coles HQ, London and Kolnischer Kunstverein, Koln

The Old In Out, Barbara Gladstone Gallery, New York

1999 *Beautiness,* Contemporary Fine Arts, Berlin

2000 *The Fag Show,* Sadie Coles HQ, London

Sarah Lucas – Beyond the Pleasure Principle, The Freud Museum, London

Sarah Lucas: Self Portraits and More Sex, Tecla Sala, Barcelona, Spain. Cat. texts by Victoria Combalía, Angus Cook.

2002 *Charlie George,* Contemporary Fine Arts, Berlin

Selected Group Exhibitions

1986 *Showroom*, London

1988 *Freeze*, PLA Building, London

1990 *East Country Yard Show,* Surrey Docks, London. Cat.

1992 *Lea Andrews, Keith Coventry, Anya Gallaccio, Damien Hirst, Gary Hume, Abigail Lane, Sarah Lucas, Steven Pippin, Marc Quinn, Marcus Taylor, Rachel Whiteread,* Barbara Gladstone Gallery, New York

1993 *Sarah Lucas and Steven Pippin*, Project Room, Museum of Modern Art, New York. Cat.

Young British Artists II, Saatchi Collection, London. Cat.

1994 *Watt,* Witte de With, Rotterdam and Kunsthal, Rotterdam. Cat.

Football Karaoke, Portikus, Frankfurt. Cat.

1995 *Minky Manky,* South London Gallery. Cat.

Brilliant! New Art From London, Walker Art Center, Minneapolis and Museum of Fine Arts, Houston. Cat.

1996 *Live/Life,* ARC Musée d'Art Moderne de la Ville de Paris, touring to Centro Cultural de Belem, Lisbon. Cat.

Full House, Kunstmuseum Wolfsberg, Germany. Cat. on CD-Rom

Masculin/Feminine, Musée National d'Art Moderne, Centre Pompidou, Paris. Cat.

1997 *Material Culture,* Hayward Gallery, London. Cat.

Assuming Positions, Institute of Contemporary Art, London. Cat.

Sensation: Young British Artists in the Saatchi Collection, Royal Academy of Art, London. Cat.

1998 *Artists from the UK II,* Sammlung Goetz, Munich. Cat.

Die Rache der Veronika: Fotosammlung Lambert, Deichtorhallen, Hamburg. Cat.

Real Life: New British Art, Tokyo Museum of Contemporary Art. Cat.

Emotion: Young British and American Art from the Goetz Collection, Deichtorhallen, Hamburg. Cat.

1999 *The Anagrammatical Body,* Neue Galerie am Landesmuseum Joanneum, Graz, Austria. Cat.

Sensation: Young British Artists in the Saatchi Collection, Brooklyn Museum, New York

2000 *Quotidiana: the continuity of the everyday,* Castello di Rivoli, Turin. Cat.

Sex and the British, Galerie Thaddeus Ropac, Salzburg and Galerie Thaddaeus Ropac, Paris. Cat.

The British Art Show 5, Hayward Gallery travelling exhibition: Scottish National Gallery of Modern Art, Edinburgh and tour. Cat.

Puerile 69: Angus Fairhurst, Michael Landy, Sarah Lucas, Gillian Wearing, The Living Art Museum, Reykjavik, Iceland

Intelligence: New British Art 2000, Tate Britain, Millbank, London. Cat.

Hypermental, Zurich Kunsthaus, Zurich. Cat.

2001 *Close Encounters of the Art Kind,* Victoria and Albert Museum, London

Public Offerings, Museum of Contemporary Art, Los Angeles. Cat.

Century City: Art and Culture in the Modern Metropolis, Tate Modern, London. Cat.

Field Day – Sculpture from Britain, Taipei Fine Arts Museum, Taiwan. Cat.

City Racing 1988–1998: a partial account, Institute of Contemporary Arts, London. Cat.

2002 *Art Crazy Nation Show,* Milton Keynes Gallery, Milton Keynes. Cat.

Index